HOTEL FOUBRIAND

PARIS

Christmas 1886

Dearest Euphemia,

Please find enclosed this photographic and watercolour album. We shall send you views of the Grand Tour, which you may place on the left hand side of your album and then copy, reproducing an aesthetically pleasing watercolour of the same view on the right-hand page. We shall send you a watercolour box from Venice.

We are informed that it is the favourite pursuit of the young ladies of fashionable Parisian salons at the moment and we do hope that you will follow their consummate example.

If something urgent arises, you may write to us in a months time at Lord and Lady Catersmole's villa in Fiesole.

Your loving Papa & Mama.

LADY COTTINGTON'S FAIRY ALBUM

For Wendy—When my words failed, hers did not.

Notice:
The notorious exploits of Lady Angelica Cottington (1888–1991) were revealed to an astonished world by Brian Froud and Terry Jones with the facsimile reproduction of *Lady Cottington's Pressed Fairy Book*, and the derivative work *Lady Cottington's Pressed Fairy Journal*, published in 1994 and 1996, respectively, by Pavilion Books Limited of London, England.

Visit the Official Froud Faeries Website
www.WorldofFroud.com

A World of Froud/Imaginosis Book
www.imaginosis.com

Designed by Emiliano Dacanay for Wherefore Art?, London
Calligraphy by Hazel Brown
A special thank you to Robert Gould, Neil Gaiman, and Constance Herndon, for their creative support.

Library of Congress Cataloging-in-Publication Data
Froud, Brian.
 Lady Cottington's pressed fairy album / by Brian Froud.
 p. cm.
 Includes the reproduction of the original Euphemia Cottington's photographic
 album, dating from the 1880's.
 ISBN 0-8109-3294-6
 1. Photography, Artistic. 2. Cottington, Euphemia. 3. Cottington,
 Euphemia-Diaries. 4. Fairies in art. I. Cottington, Euphemia. II. Title.
 TR652 .F78 2002
 398'.45-dc21

 2002066828

Published in 2002 by Harry N. Abrams, Incorporated, New York
Printed and bound in Hong Kong
10 9 8 7 6 5 4 3 2 1

 Harry N. Abrams, Inc.
100 Fifth Avenue
New York, N.Y. 10011
www.abramsbooks.com

Abrams is a subsidiary of
LA MARTINIÈRE
G R O U P E

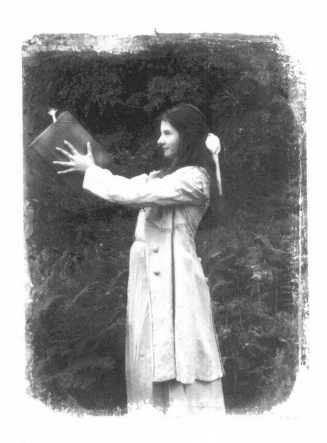

LADY COTTINGTON'S FAIRY ALBUM

In the final years of the last century, *Lady Cottington's Pressed Fairy Book* was discovered and revealed to an astonished world. Angelica Cottington had perfected the technique of pressing fairies in between the pages of a remarkable diary she kept from 1895 to 1912. As a child, Angelica had captured her first fairy impression quite by accident, by slamming a flower-pressing book shut on one of the lovely but aggravating creatures as it alit in the margin.* She devoted the rest of her long and increasingly eccentric life to the avid pursuit of fairies, in the process creating a historic collection that she hoped would provide proof of fairy existence. When *Lady Cottington's Pressed Fairy Book* was published in 1994, it was shocking to realize how much Angelica's obsession with squashing her subjects flat had obscured her original scientific intent. However, recent discoveries have revealed that much of what we assumed about Lady Angelica Cottington's life was partially or totally wrong.

For many years it was thought that *Lady Cottington's Pressed Fairy Book* was the only document that this infamous fairy squasher had left behind. Then, last year, I was contacted by Messrs. Grabbitt and Rhunne, solicitors representing an unnamed party. It appears that shortly before her death Lady Cottington had entrusted this person with several steamer trunks filled with memorabilia, notebooks, drawings, poems, paintings, and scrapbooks; there were also, I was told, ancient magnetic audio tapes and even some reels of cinema film. Having had a hand in presenting the original book to the public, I was asked if I would be willing to undertake a similar task again — to work with international academics and historians to codify and assemble the material in the Cottington Trunks into a form in which it could be presented to the public.

Having received much undesired attention in my first outing with Cottingtoniana, I said no. I was also confident that nothing in the steamer trunks could have the impact upon me that the pressed fairy book had. But a week later a brown paper parcel arrived at my door, for which I reluctantly signed. Inside laid a rare Victorian photographic and watercolour album, of which the volume you now hold is a reproduction. I read it in amazement.

*We are pleased to publish here a very rare photograph (courtesy of the Cottington Archives) of Lady Cottington as a young girl in the actual act of squashing a fairy.

For years, experts have puzzled over an enigmatic, faded photograph held in the secret vaults of the Bibliotèque des Fées Historique in Paris. It seems to be a record of an etheric fairy form, but its origins, its date, and the identity of the photographer have until now been unknown. With the release from the Cottington Archives of *Lady Cottington's Fairy Album*, we learn the true authorship of this priceless photo—and much more besides.

The album, dating from the 1880s, is presented here in facsimile form—every subtlety and nuance faithfully and painstakingly reproduced. Obviously the album had been in young Lady Angelica Cottington's possession—its singular contents were commented upon and in places almost obliterated by her fairy pressings. The photographs, however, seem to have been made by Angelica's older sister, Euphemia, who passed away when Angelica was a small child. The album's photographs and messages exhibit Euphemia's extraordinary relationship with fairies. Although born into a society of privilege and restraint, the young woman struggled to break free both emotionally and physically from all its stultifying restrictions. For her, fairies were a gateway to freedom. In these pages, we find expression of that freedom and of deep loss as well: loss of innocence, loss of faith, and loss of underclothes.

Since photography's invention, charlatans have attempted to convince a skeptical public that authentic spirits can be captured on camera. In 1862 William H. Mumler, an American amateur photographer and engraver, claimed to have taken "the first photograph of a soul that had passed over." One of many such bounders, he was successfully prosecuted for forgery. Euphemia's own photographs initially appear to be forgeries as well—no one could mistake the fairy creatures in the early images for anything other than dolls or paper cutouts. However the later photographs and the text are deeply convincing and appear, as far as we can tell, to describe genuine fairy contact for the first time. Experts have thoroughly examined the photographs, although to date no negatives have come to light. While Euphemia never mentions her technical working methods, one can deduce that she possessed a hand-held camera such as a Watkins Pocket Camera or a "momentograph." These were plain wooden boxes with a lens, which used dry-plates that could make exposures in fractions of seconds—not like the old, slow, wet colloidal glass plates. This meant she was perfectly equipped technically to capture the fleeting and elusive fairy phenomena she claims to have encountered in the woods.

Euphemia's prints were produced in various ways. Many are albumen prints, others are on printing-out paper or "pop," and we even find the occasional salt print. Some particularly mystifying photographs were produced in a yet-unknown way. (The Cottington Archives has resolutely refused permission to submit these to chemical analysis.) It must be presumed that Euphemia developed and printed her own photographs, a difficult enterprise requiring often-hazardous chemicals, which some have suggested may have produced hallucinogenic fumes.

For me, and I hope for you, the album was a revelation, although an examination of the writings and the images raises as many questions as it resolves. Here, at last, has Euphemia Cottington provided irrefutable evidence of fairy existence? How did she capture on film that which has been so elusive for so long? What really happened to Euphemia? And did Angelica *never* open the letter proffered her at the end of the book?

I have my own theories and hypotheses, which I will keep reserved at this time. It is possible that my theories will be vindicated when further material from the Cottington Archives is made public—or, just as likely, be disproved. For now, dear reader, I think it is safe to say that your guesses as to the puzzles that lie within this book will be every bit as good as mine.

BRIAN FROUD
Devon, England

January 3, 1887. What a pleasing gift! Mama and Papa sent me this album before they left Paris so that I may keep in it momentoes of their time abroad and hopefully improve my skills as a painter of watercolours. I have spent the greater part of the last year in a darkened room, my head aching and fatigue my constant companion. How I wish that I could join Mama and Papa on the continent, but until I regain my health I fear I shall always be left behind.

PLACE VIEW HERE

I saw the tiny shimmering lady at the window again and told my governess Miss Tandy. At first she did not believe me and became very angry, telling me that I must never lie about such things, but then she grew afraid and said that it may be the brain fever returned. It has not! I know what I saw but I will not speak of it to her again. — Having read that the fairies are drawn to pretty rhyme, I opened the window and recited this poem my grandmother taught me into the night air.

Pretty fairies, bright and gay
Come and play with me this day
A gilly flower, a fairy's bower
A mouse's bone, an elfin home
I call you to me, and I pray
To see you always if I may.

I saw nothing, alas. But when I woke from my afternoon nap, I found that my headache had left me for the first time in months, and I feel as healthy as any sixteen-year-old young lady should. It is a small miracle!

13th Jan. 1904. It is my birthday today, and I am sixteen. Practically a young woman. In keeping with my advancing age, I have resolved to stay far away from the preposterous fairies.

I have not pressed a fairy for several months, nor do I intend to ever again.

The weather is mild, more like May than January, and this morning I set out to collect snowdrops. On the border of the woods, I thought I saw a young woman, dressed in an unseasonably thin gown. I called to her, but when I reached the place she had been standing in, I saw no one, and no footprints in the snow beneath the trees but my own.

But near where the woman had been standing, I discovered this photograph album! Untouched by weather and, wonder of wonders, I percieved from the signature that it had belonged to my sister Euphemia, dead now of influenza these last twelve years. Truth to tell, I barely remember her, save as someone who held me tightly and sang to me and made me laugh. I was only four but how I cried when Papa said she had suddenly passed away.

That was the last time he spoke her name and overcome with grief, he removed all likenesses of her from the house.

Perhaps I shall give this album to Papa and Mama when they return from London tonight.

But first I shall read it.

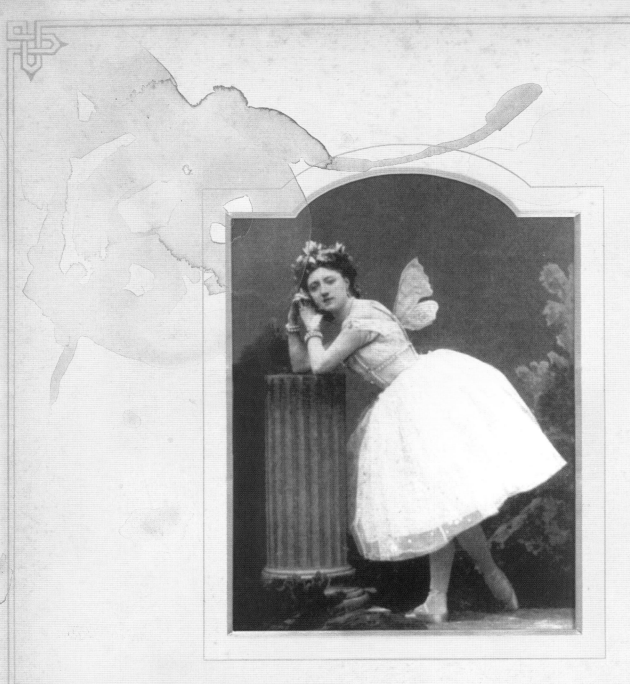

February 14th

Tonight I saw a most marvellous thing. Fairies on the stage! Uncle Humphrey has taken me to the theatre to see my very first ballet, La Sylphide.

Oh, the beauty of those fairies dancing so gracefully across the stage with their darling little toes barely touching the ground.

Uncle Humphrey made a rather typical suggestion that the dancers would look more like real fairies without their wings or what he called their "silly" costumes, but I thought that they were quite, quite perfect in every respect. Indeed I wish that I could see them always and learn to dance as they do.

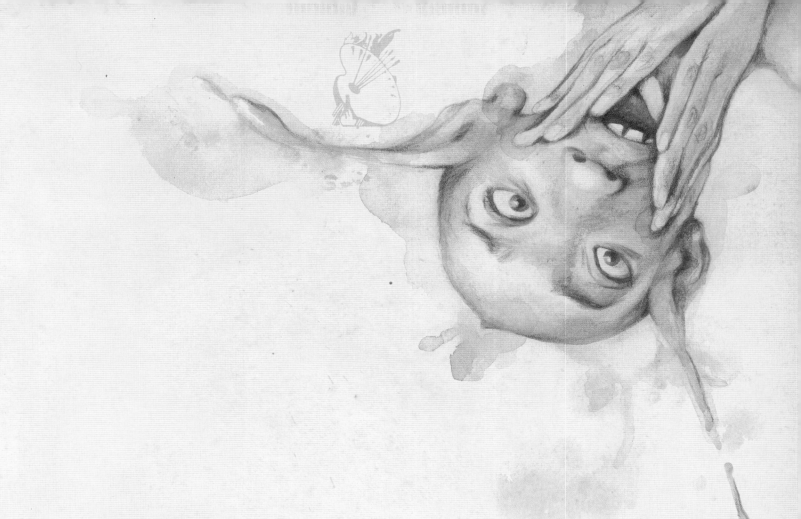

It is difficult to find a safe place to sit and read, and I find myself swarmed over by pestilential fairies, which flutter about my head and about the album like gnats. Strange for I have not seen a fairy in months. I snapped the book at them in an attempt to frighten them off, but I appear to have squashed one entirely by accident.

Dear me — I didn't mean to, really I didn't!

I've tried to rub the stain away but no use. I daresay it deserved it, but it saddens me to have soiled such a lovely book. Euphemia has been so tidy in her musings.

So Euphemia took photographs of fairies too! Her fairies look somewhat different to the ones I see.

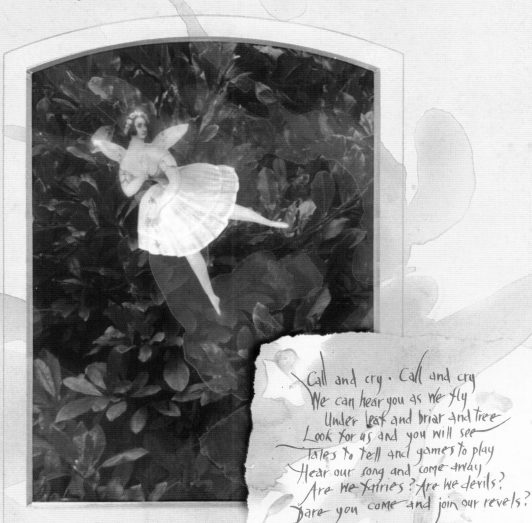

Call and cry. Call and cry
We can hear you as we fly
 Under leaf and briar and tree
Look for us and you will see
Tales to tell and games to play
Hear our song and come away
Are we fairies? Are we devils?
Dare you come and join our revels?

March 20th

I have taken tea with the fairies in our wood. Acorn cups for tea and flower petal tarts arranged on leaves. We had our tea party in the mossy glen quite away from the edge of the wood. And I took my first photograph! Dear, darling Uncle Humphrey presented me with a camera and he said that I could photograph my tea parties and any fairies that appear to me in the wood. He laughed so when he talked of the fairies that I do believe he was making fun of me. I will not let him come to the wood — the fairies would not show themselves if he were there, but I suppose I must let him see the photographs if I succeed in capturing a fairy's image.

I am extremley pleased to have recieved the camera, especially since neither the promised views or watercolour box have arrived. ~ The fairy I photographed looked curiously flat when I saw her in the picture and she wasn't flat at all really....... just fluttery! A fairy captured in a photograph is not the same as seeing them all around me.

I must try again ~ I will not show Uncle Humphrey ~ I do not think he would appreciate my effort as yet.

At least in her photograph they are still not waving around parts of their anatomy I cannot bring myself to even think about, let alone write down. They tangle my hair or wet my dress or make rude remarks or perform some absurdity in my face.

SWOMPPPH!

Like right now—

How can I concentrate!?

I took a photograph of a fairy last year but Papa took it from me, and my camera as well.

Dance with us Euphemia — the hour is late
The piper is piping and we will not wait.
We know that you wish to — we know you are bold.
Come dance with us Effie — the day soon grows cold.

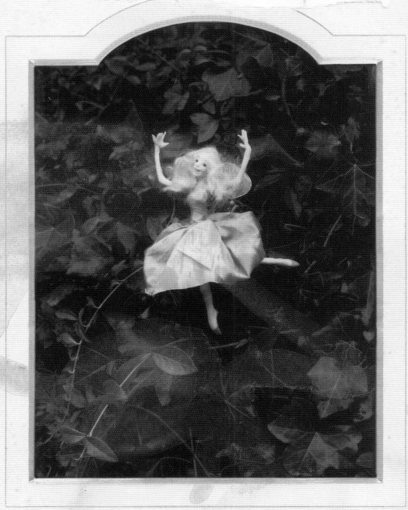

March 25th

I observe that the fairies all have bare feet. It is a curious thing.
They must always run through the dew on tiptoe, their feet cool and
clean in the grass. Now I have done the same! I unbuttoned
my boots and rolled down my stockings. I put them in my pinefore
pocket and wiggled my toes in the grass. What a lovely feeling it was.
I felt very wicked though!

Naughty fairies! They have stolen my shoes and hidden
them. I shall have to tell Miss Tandy and she will be furious,
although they were my oldest shoes.

Well! The fairies had better not invite me to their revels! Imagine such a thing — no shoes or stockings! Why cannot Euphemia see them for what they are — secretive, shallow, in my experience — incapable of civilised behaviour.

It's enough to make one want to teach them a lesson. Euphemia recieved little notes and invitations. I recieve nothing but irritation. Why won't they let me read in peace?

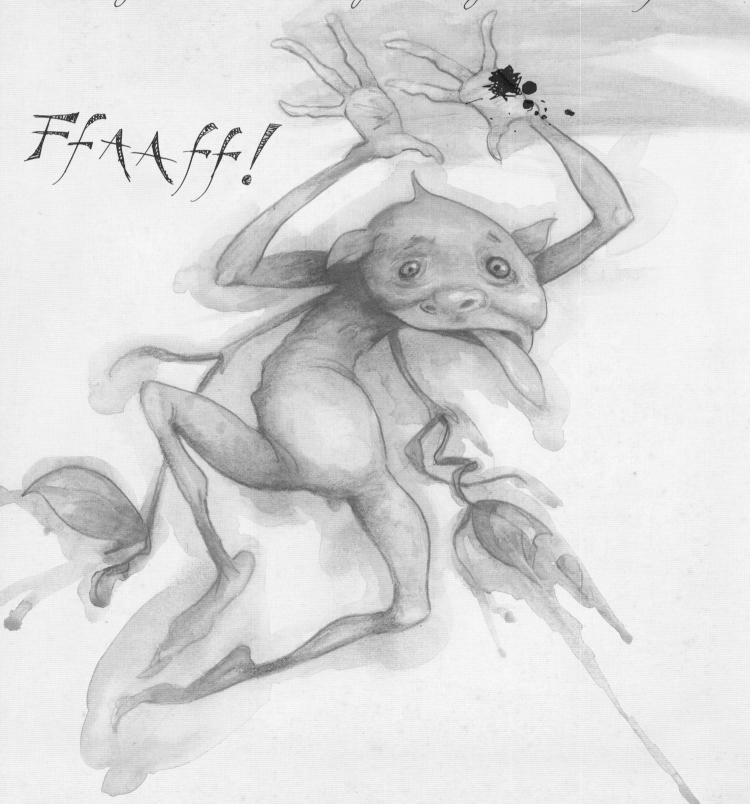

FFAAff!

March 28th

I composed a song especially for the fairies. I knew that if I could sing it prettily enough they would come and sit by me, and they did! So many of them sitting in a circle with their eyes shining and their wings fluttering ever so slightly as they listened.

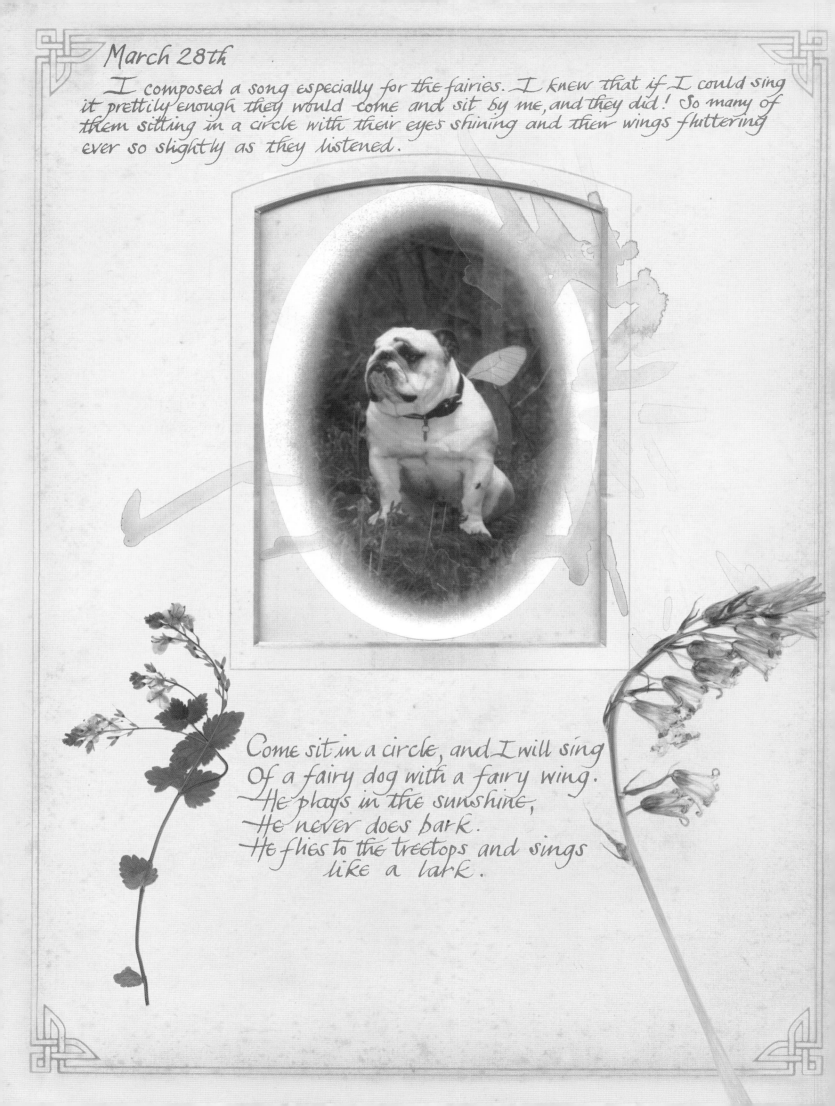

Come sit in a circle, and I will sing
Of a fairy dog with a fairy wing.
He plays in the sunshine,
He never does bark.
He flies to the treetops and sings
 like a lark.

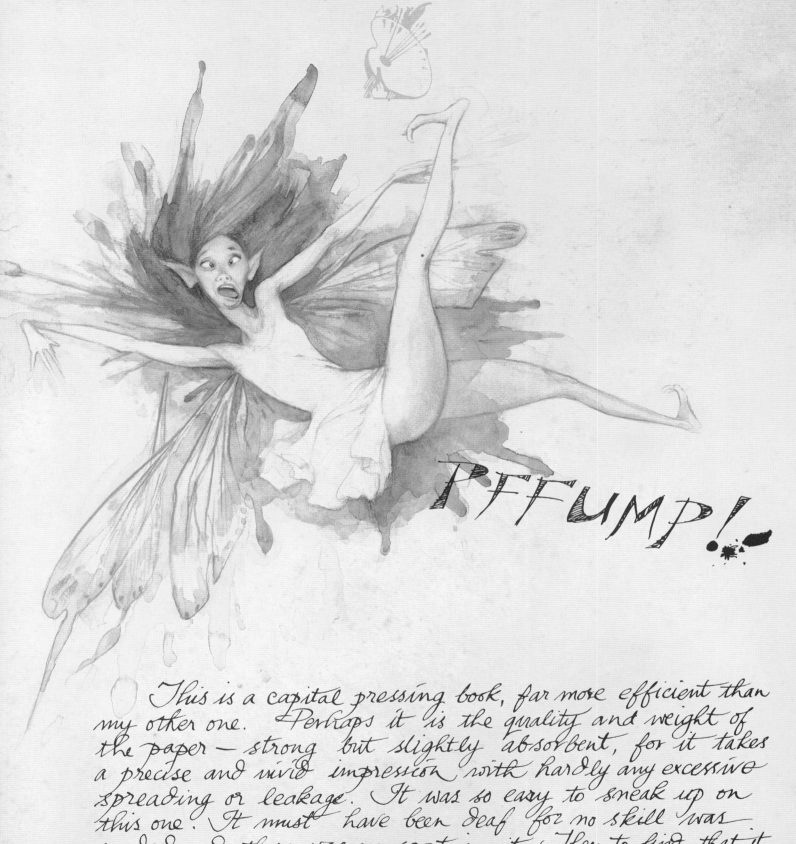

PFFUMP!

This is a capital pressing book, far more efficient than my other one. Perhaps it is the quality and weight of the paper — strong but slightly absorbent, for it takes a precise and vivid impression with hardly any excessive spreading or leakage. It was so easy to sneak up on this one. It must have been deaf for no skill was needed and there was no sport in it. Then to find that it was a fairy of no great rarity — in fact, it was rather common. I would hate to spoil such a superior album with inferior specimens. Euphemia seems to have taken a photograph of a particularly odd fairy — quite ugly!

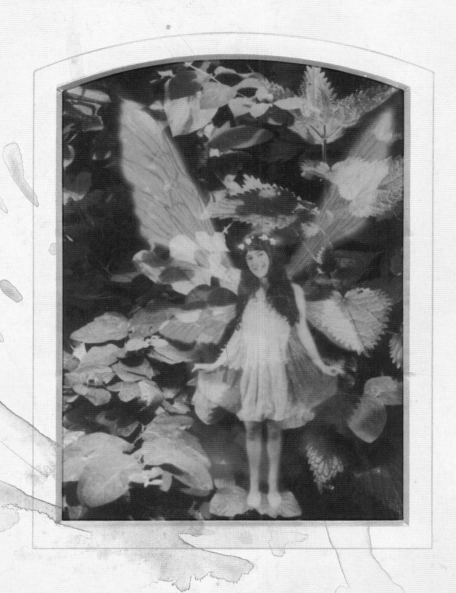

April 1st

Spring has arrived in its full glory and primroses and violets carpet the clearing in the centre of the wood. I walked barefoot with two lovely fairies and we picked flowers to make crowns. When I wore my flower crown, for a few moments I felt like a fairy princess.

I forgot to remove it when I left the wood to return to the house. We have a new gardener's boy and I do believe he saw me wearing my crown because he was smiling quite boldly at me as I went up to the house.

To avoid the fairies and to warm up I have taken refuge in the kitchen in front of the kitchen fire. Within several minutes, though, the little winged flitterers had found me and commenced to distract me, dropping sultanas on my head and, in one case, flying to Cook's flour bin, before diving onto this book.

FFOomph!

Flour everywhere!

But not in vain, for I appear to have pressed my first flour fairy.

Cook is VERY CROSS!

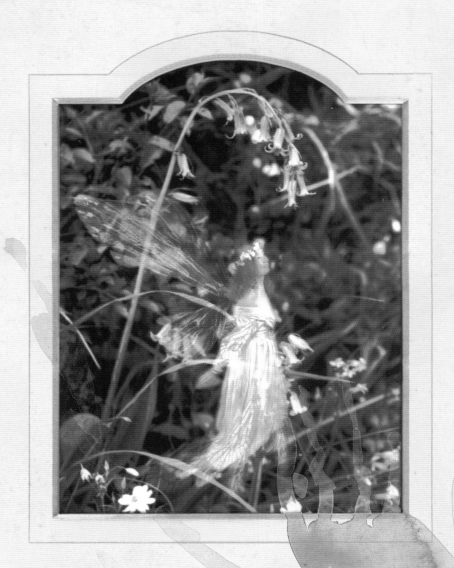

April 3rd

Uncle Humphrey came to dinner today and asked to see the results of my photography but I told him that, alas, I had not had much success and would not presume to bore him with my poor efforts. I do hope that the picture I took today will look at all like what I saw.

He said he waits with impatience for, as he put it, "just a glimpse of gossamer my dear, just a wee look at the winged lovelies." He exhibits altogether too much interest and I am certain it is not healthy for him!

Uncle Humphrey died in Paris several years ago. I recall Papa once saying to Uncle Victor that when he died, enthralled by the Green Fairy of Absinthe, all the Ladies of the Evening of Montmartre wore black lace unmentionables for a week to mourn their favourite gentleman—friend. (A Lady of the Evening must be something they have in France.)

The fairies tried to hide this picture from me, descending on the page and obscuring my view. Foolish creatures! There is no purpose or sense to anything they do.

I hardened my heart, and CRUMP!

Messy, but effective. I am perfecting my technique. One has to be very quick indeed, then a firm squeeze. One learns in time to ignore the little cries.

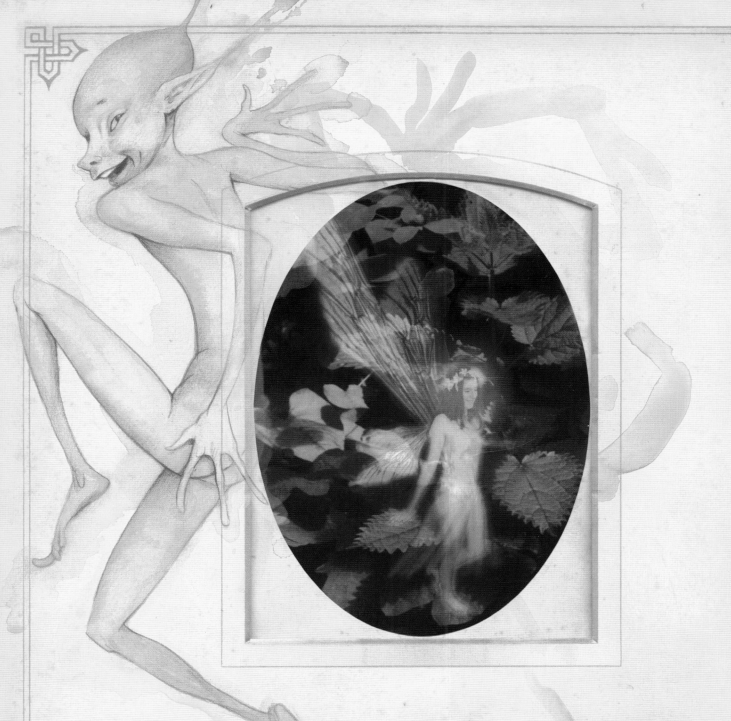

April 5th

Rain! Torrents of it. I shall have to amuse myself indoors today.
I wonder if the fairies will be dancing in the rain. I very much doubt it.

I slipped out of doors this afternoon between rain showers just to see if I
could spot a fairy or two. Well! Indeed I did and they were
cavorting in a most free and easy manner, each one wetter than the
next and terribly happy with it.

I was caught in a downpour as I returned to the house. I suspect
that my clothing may be quite transparent when wet, just like the
fairies. The gardener's boy was sheltering under a tree and I know
that he could see my legs quite clearly through my skirts. I did
not care. I walked most slowly and turned my face up to the sky
just to feel the raindrops on my eyelashes.

I do think that raindrops are prettier than diamonds.

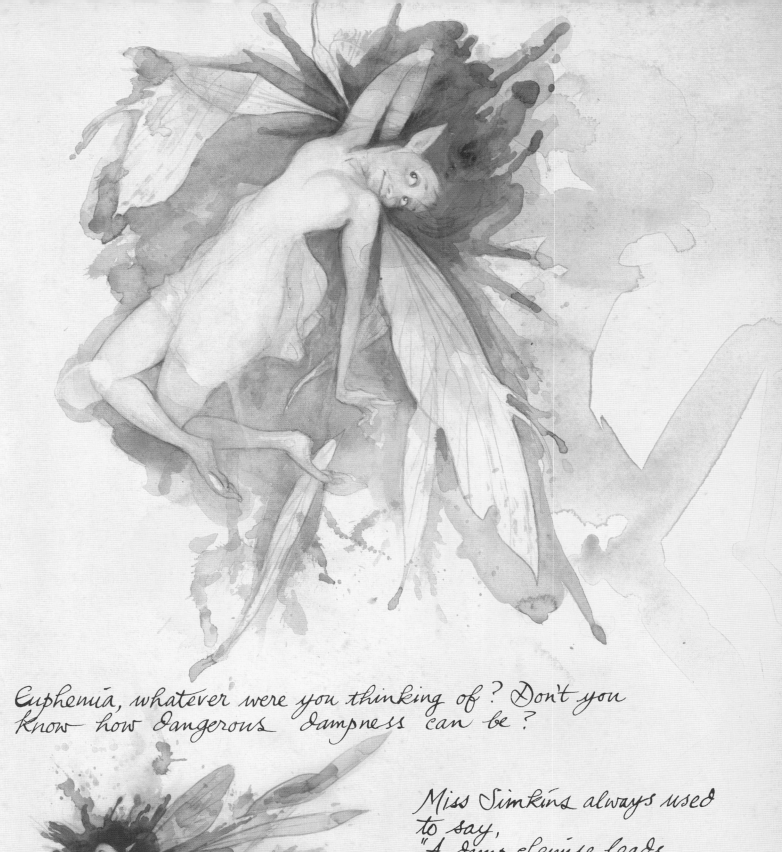

Euphemia, whatever were you thinking of? Don't you
know how dangerous dampness can be?

Miss Simkins always used
to say,
"A damp chemise leads
to a sneeze."
But with you I fear it
will lead to worse!

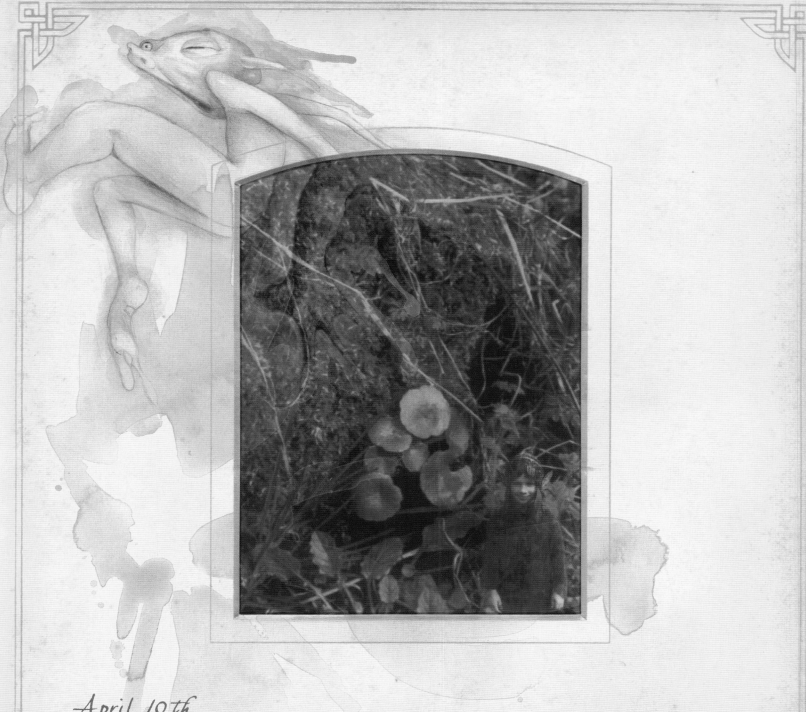

April 10th

Today is my birthday and I have had another note under my pillow. How did they know, for I am certain that I never told them. But I shall come as they have asked me to. I wonder if I shall feel older. "Older and wiser, I always advise her, is not as much fun as a tickle and pie sir." One of Uncle Humphrey's silly rhymes, which he whispered to me while helping me down from the carriage yesterday. He does speak such nonsense.

I lay in bed this morning with my eyes shut tight and just felt what it was like to wake up and be seventeen years of age. I am myself, but more myself than I was yesterday. I shall go to the woods while everyone is still asleep.

Closing the curtains and locking the doors did not keep out the fairies. They are whispering and giggling as I read. I shall not allow them to distract me. They are so forward with their backward parts!

A birthday note for our beloved Effie —
Come show us your ankles
You know it will please
Then dance with us Effie
And we will not tease

SLAM! SLAM!
Thinner than sliced ham!

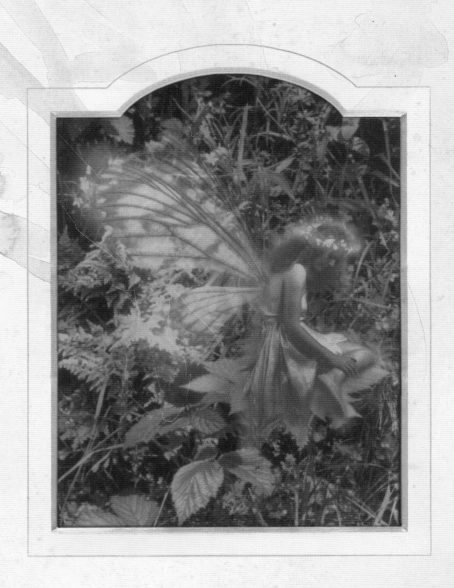

April 11th

 I danced with the fairies! They were waiting at the edge of the wood and they plucked at my clothes and pulled me along deep into the wood. So pretty they were in their gossamer shifts, leaping and turning in the air. Uncle Humphrey would have been delighted — all the more reason not to tell him. I became quite hot in my dress and petticoats and the fairies could see this for they soon asked me if I would not like to remove my outer garments and dance in my petticoats alone. Well, if they had asked me the same question yesterday when I was but sixteen I would have refused in no uncertain terms.........

 Oh! The freedom of it all. I could leap and dance as lightly as them.
 They flew about my head, pulling the pins from my hair until it rippled and floated on the wind.

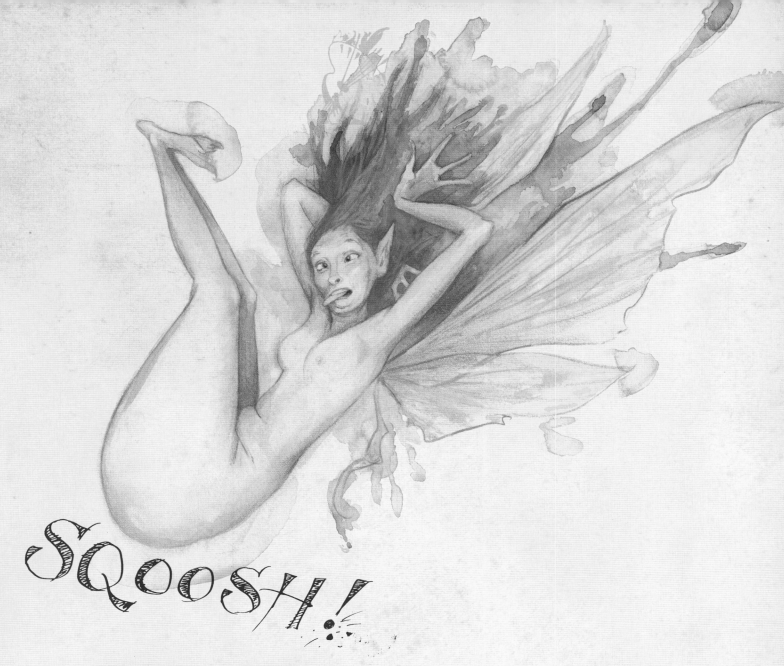

SQOOSH!

Euphemia, sweet sister! I blush for you, although you are safe in your grave and beyond all blushes. How could they have tempted you so? First it was shoes and stockings and then.........Oh heavens! I can't ~~bare~~ bear the thought.

I will not dance with them. I do not dance. Mama says it is the root of all evil, and once she said that what took away my sister was something she caught while dancing. I do not forget. Influenza lies in wait behind every foolish smile and undressing, and too late it is for many who disregard this advice, when angels call for new playmates in Heaven's garden.

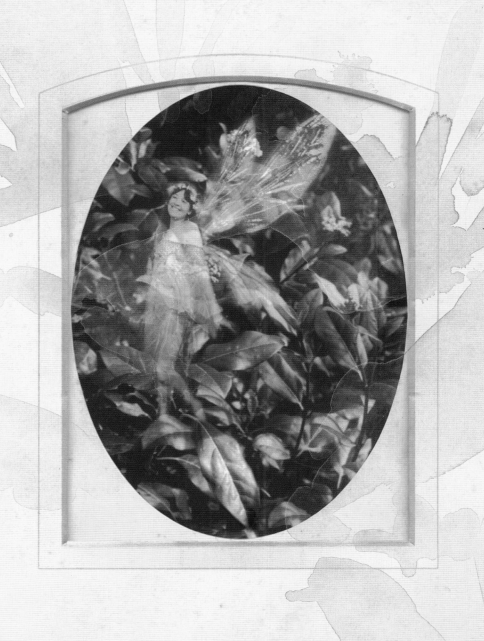

April 15th

 The gardener's boy has given me a flower. He says that it is a new variety that no one else has seen and he would like the honour of naming it after me as a birthday gift. I believe I shall let him.

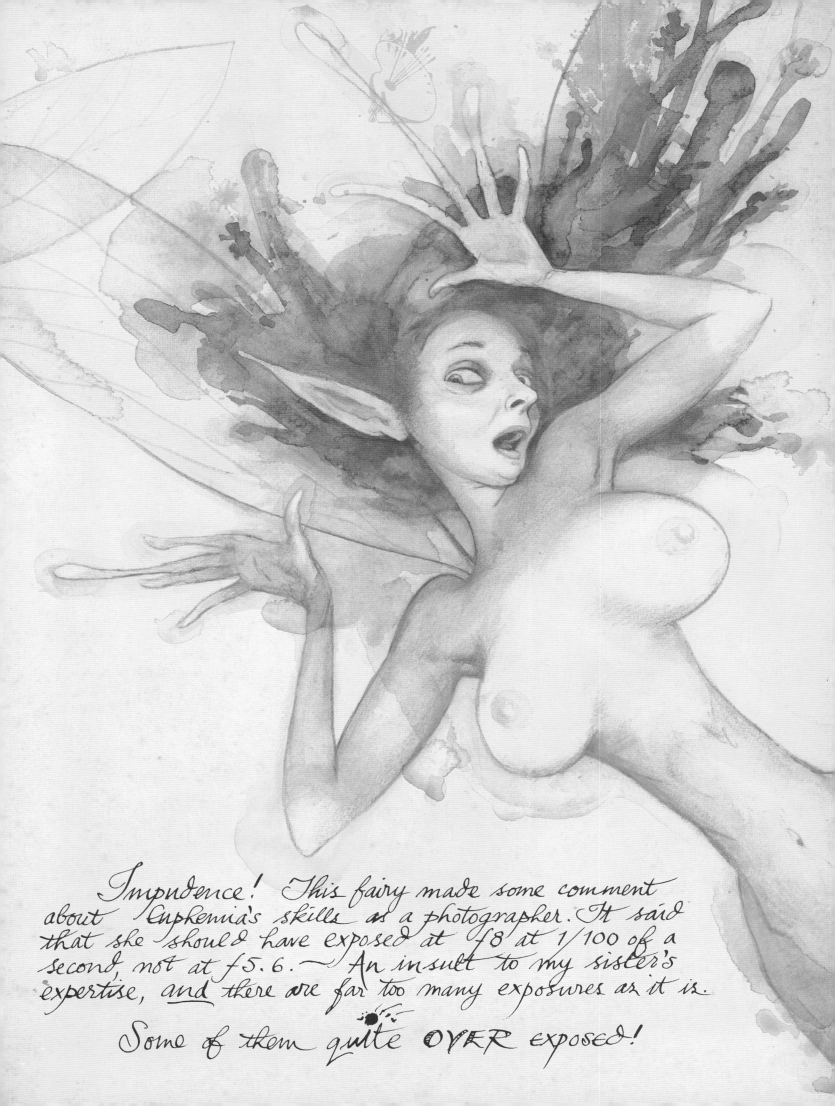

Impudence! This fairy made some comment about Euphemia's skills as a photographer. It said that she should have exposed at ƒ8 at 1/100 of a second, not at ƒ5.6. — An insult to my sister's expertise, and there are far too many exposures as it is.

Some of them quite OVER exposed!

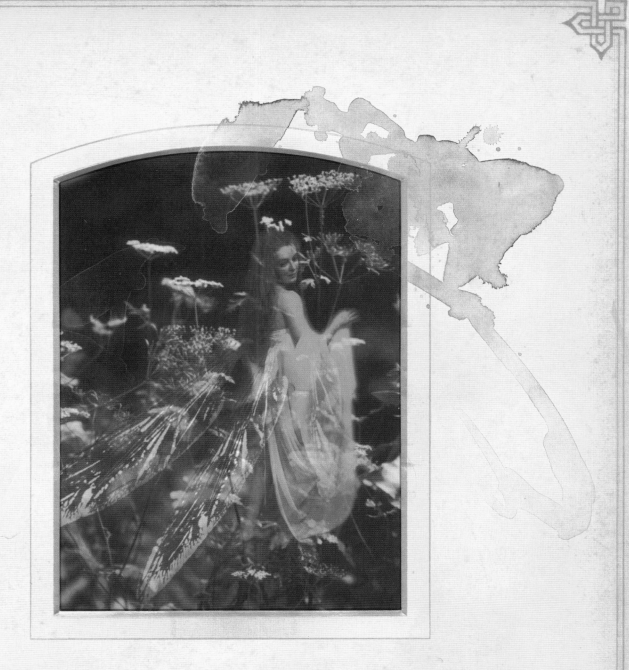

April 20th

I slip away to the wood daily now, not caring what the weather may be. I must say that this is becoming easier with every passing day because Miss Tandy does not seem to notice whether I am in the house or not. She has been suffering from terrible toothache and must deaden the pain with her medicine at least once every half hour — then she is an absolute lamb and smiles ever so sweetly at me when ever I tell her that I'm going to take a short walk in the garden. I must say that her medicine smells remarkably like whatever it is that Uncle Humphrey keeps in his hip flask.

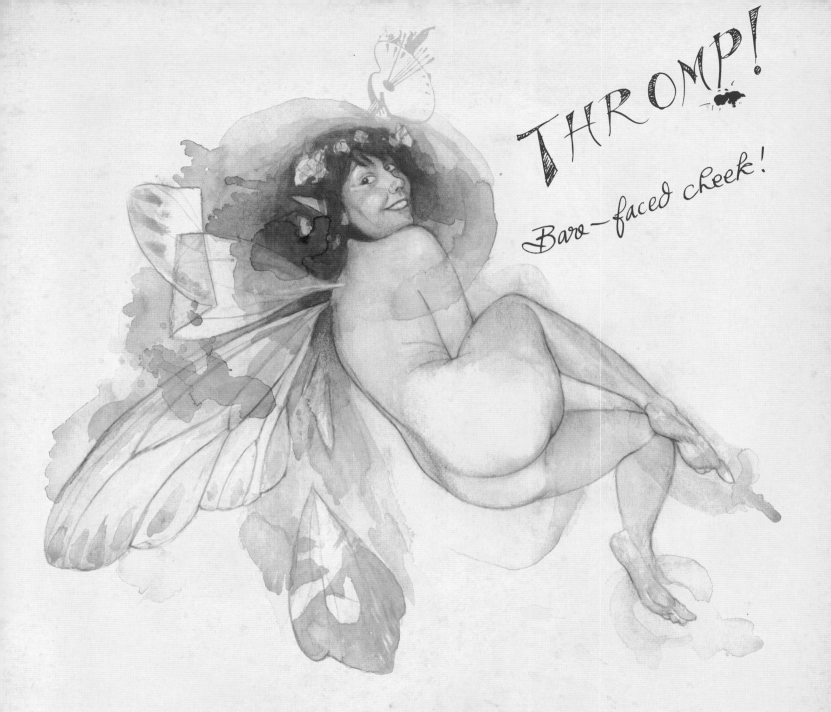

THROMP!

Bare-faced cheek!

There is so much I do not understand. Why does
Euphemia go with them? I fear for her modesty.
Once a little fairy tried to tell me something and
whispered in my ear and then pulled up my skirts
exposing my ankle — and in the presence of Lord
Shafleton as well! (His spectacles became quite
fogged.) I did flatten it immediately — a bit
awkward as it had tried to hide on Lord Shafleton's
posterior but one must assert mastery over the fairies
or they will try anything.

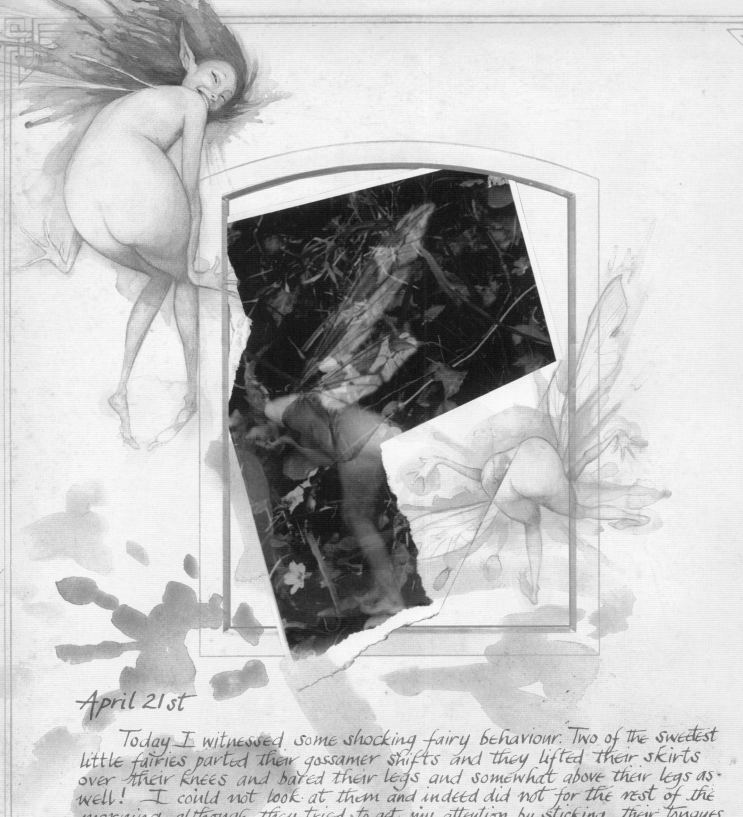

April 21st

Today I witnessed some shocking fairy behaviour. Two of the sweetest little fairies parted their gossamer shifts and they lifted their skirts over their knees and bared their legs and somewhat above their legs as well! I could not look at them and indeed did not for the rest of the morning although they tried to get my attention by sticking their tongues out and dancing a most ridiculous quadrille. I must confess that I laughed, although I tried very hard to pretend I was not paying attention.

Just before I resumed my outer clothing and left the glade, I turned around, pulled up my petticoats and danced a few steps with my drawers in full view. The fairies fell about laughing and shouting and kissing me in their delight. Such strange creatures they are. I just had to take a photograph.

Oh sister! How could you expose yourself to such entirely provocative behaviour! I myself shall keep my clothes securely fastened. As I've always said, a robust vest must be worn at all times. I wear mine under my chemisette, with my French chemise over that. This gives a safe anchor for a sturdy sanitary corset, with its own corset cover with side forms and integral dress protectors.

There is much in the world of the undergarment that needs attention. I plan to publish a pamphlet.

The Rev. Peebles is taking a keen interest and converses regularly with me on the subject in precise and knowledgeable detail. We are gradually working our way through the list of my improvements to underwear.

The Reverend, bless him, is very enthusiastic and says he cannot wait to get down to my under-drawers.

This will be some time, however, as we are still at the top with my vest extension neck protectors.

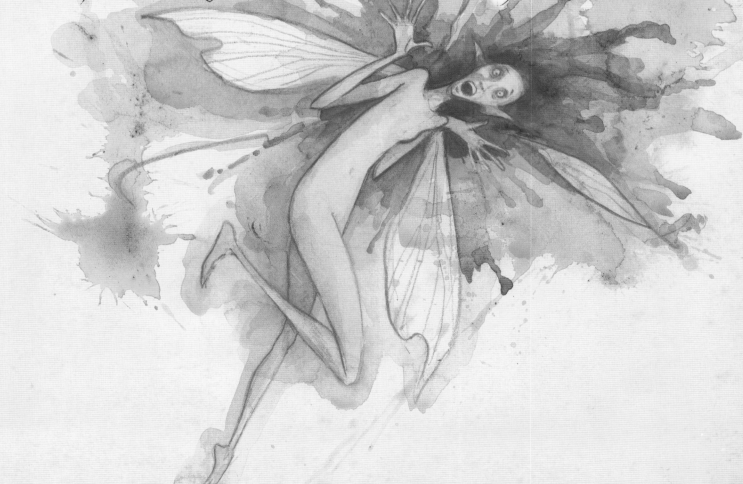

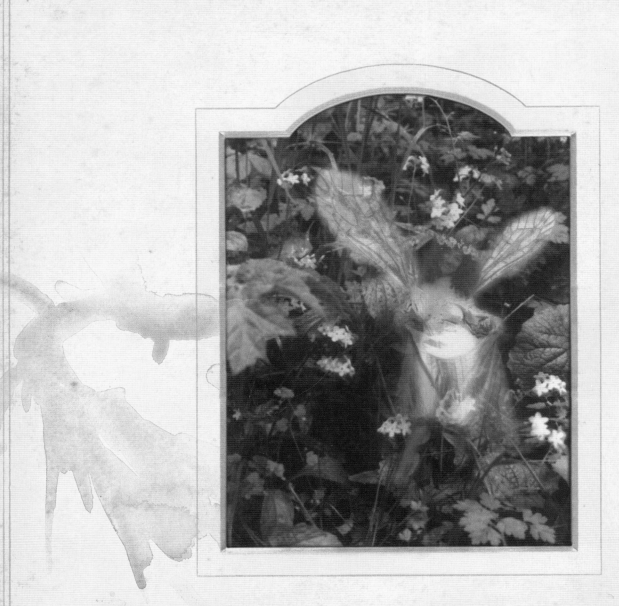

April 23rd

 Uncle Humphrey came to visit today. He was sporting a new waistcoat in what I can only describe as a terrifying colour—! He was very pleased with himself and I had not the heart to tell him what I thought. He had been to Paris and spent much of our conversation at luncheon telling me of the "lovely ladies, those exquisite butterflies of fashion" whom he nightly accompanied to the opera. Then he became quite serious for a moment and looking at me in ever such a strange way, inquired, "and how are the fairies, my dear?"

 I blushed~I know I did, and stammered my reply that they were as they were. I could think of nothing more to say and quickly steered the conversation away on to a safer subject.

 Uncle H. was quite happy to indulge my interest in the somewhat lurid topic of Parisian nightlife.

When I was a little girl Uncle Humphrey would give me half crowns so I would show him my pressed fairy book but he told me that pressing was too good for the little people. (He did not use the word 'people', but when I repeated what he said to Miss Simkins, she washed out my mouth with soap and I shall not write it here.)

SLOMPP!..

I'm absolutely certain
it was up to something.
But I stopped it
just in time!

April 25th

I had no notion of what would befall me as I entered the wood this morning. The most beautiful of the fairy host leapt up and declared solemnly that a contest was to be held on this day to discover who could invent the most cunning rhyme. I gladly began the proceedings by reciting a lovely poem about a sheep that I had written earlier this year.

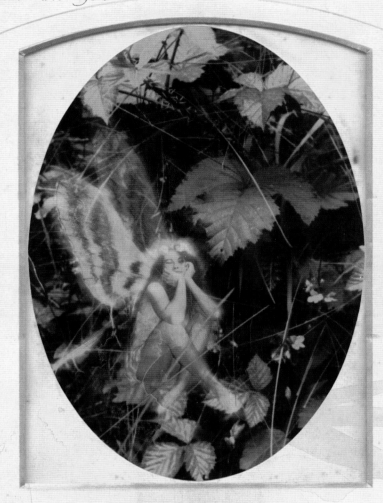

I was rather proud of it but the fairies were not in the least impressed. Then one cheeky fairy stepped forward and recited a poem of such rudeness that I was quite taken aback. The fairies cheered wildly and looked expectantly at me. I remembered something that Uncle Humphrey had recited once after dinner and holding back my blushes, I replied by reciting ~

As I reached down to pick some clover
I bumped an elf and knocked him over.
I said I knew he'd had a fright, and
asked him if he felt alright.
From where he lay upon the ground,
his voice boomed out with joyous sound:
"Don't worry miss, it does not hurt,
I'm happy looking up your skirt."

They enjoyed it greatly, but then — oh, the shame of the next offering from that fairy mouth. I blush to remember it and try as I might, I cannot bring myself to record it here. Suffice to say, I told them that I had no rhymes to match and would concede to the winner. Now I must pay a forfeit for ending the game so abruptly. They wish to watch me dance, at midnight, in the wood. I shall be brave for after all, it is only the night, and only the fairies who will see me.

Before luncheon I hid the album under my bed in case the fairies tried to steal it as they did my pressed fairy book. We had pressed tongue sandwiches and tapioca pudding — my favourite! Miss Simkin must have remembered my birthday after all. — After my constitutional, I looked for the mysterious woman I had seen so fleetingly this morning but I found nothing. The book was safely beneath my bed on my return and I discovered a fairy sleeping between these pages. It did seem such a pity to wake her up, so I didn't. SCROOOSH!

This would be my
contribution to their contest..!

"When fairies fly about my hair
I squash and smash til they aren't there!"

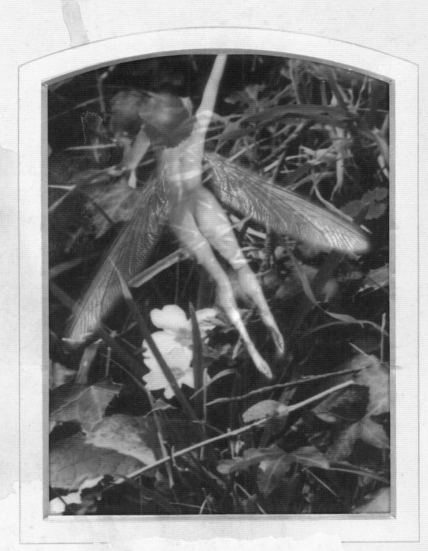

Not at night Euphemia! Not in the woods! Can't you see what a dangerous combination fairies and moonlight are?

juice of clover . juice of rose
stain your eye-lids/ paint your nose-
juice of daisies we confess
all you need in place of dress

April 26th

 I promised I would come and so I did, walking into the glade with my heart beating so wildly I thought it would burst through my nightgown.

 Lights floated among the trees and the ripple of fairy laughter greeted me as I approached. Fairy pipes began to play a sweet, sweet melody that made me want to laugh and cry and dance all at the same time. We danced in a circle, faster and faster until we were a blur of light among the trees, our bodies shimmering like stars. Oh, the feel of the moonlight on my skin. I did not know one could feel the moonbeams as they shine upon the earth but it is true...........

These fairies are so tiresome — why must they grin and pull such horrible faces?! They whisper secrets to each other, secrets they keep from me. They've become frightfully forward, unspeakably brazen. Where is their shame? Where is their moderation? Where are their drawers? I am quite aware that the fairies are unencumbered by modesty, but Euphronia —

you as well?

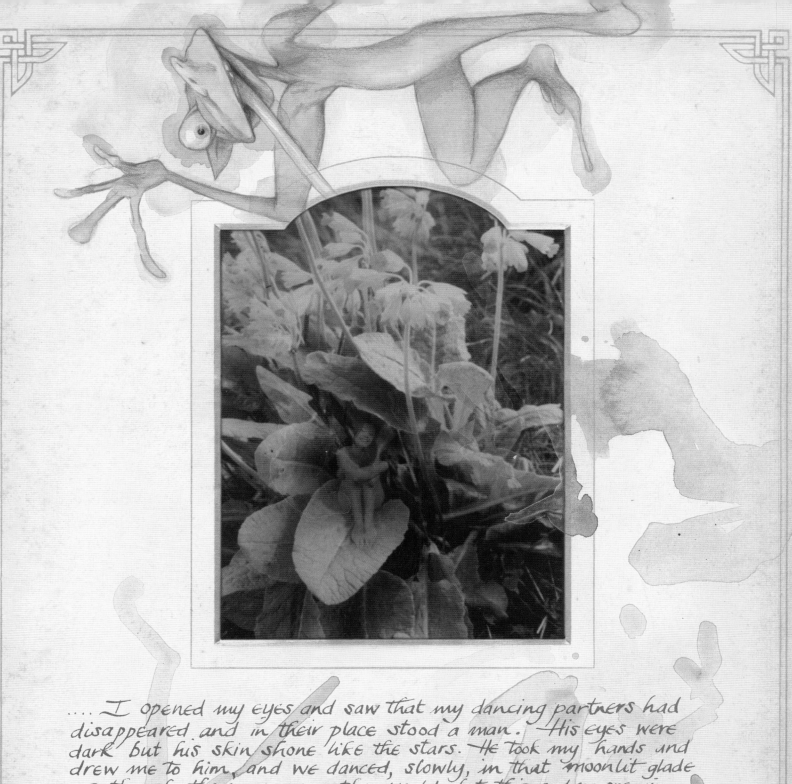

.... I opened my eyes and saw that my dancing partners had disappeared and in their place stood a man. His eyes were dark but his skin shone like the stars. He took my hands and drew me to him, and we danced, slowly, in that moonlit glade as though there were no other world but this and no one in this enchanted world but the two of us.

I have never imagined anything like the touch of his hands, his lips. We danced, and when I next opened my eyes I lay shivering and alone in the cold dew of dawn.
I grabbed my slippers and dressing gown and, buttoning as I ran, I fled the wood and returned to the warmth and safety of the house.

Oh Euphemia — no matter how many buttons you have on your dressing gown, I fear there will never be enough.

Little beasts! Will you not leave me in peace!

PFFUMPH!

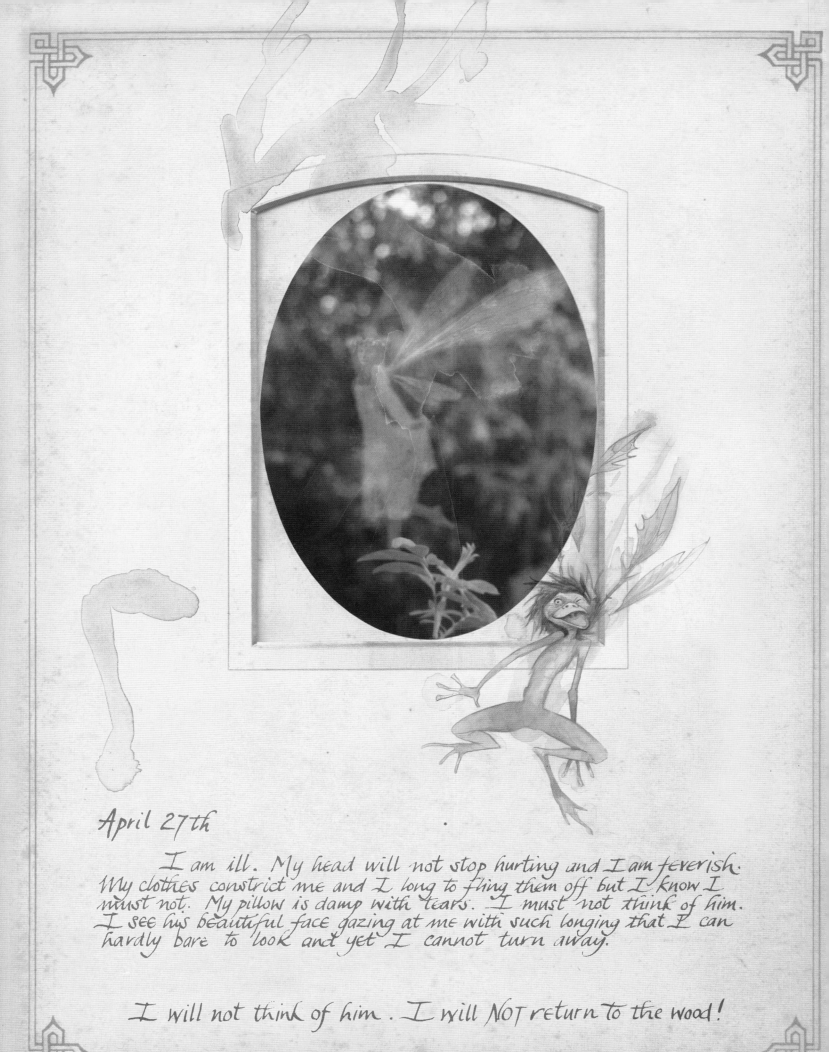

April 27th

I am ill. My head will not stop hurting and I am feverish. My clothes constrict me and I long to fling them off but I know I must not. My pillow is damp with tears. I must not think of him. I see his beautiful face gazing at me with such longing that I can hardly bare to look and yet I cannot turn away.

I will not think of him. I will NOT return to the wood!

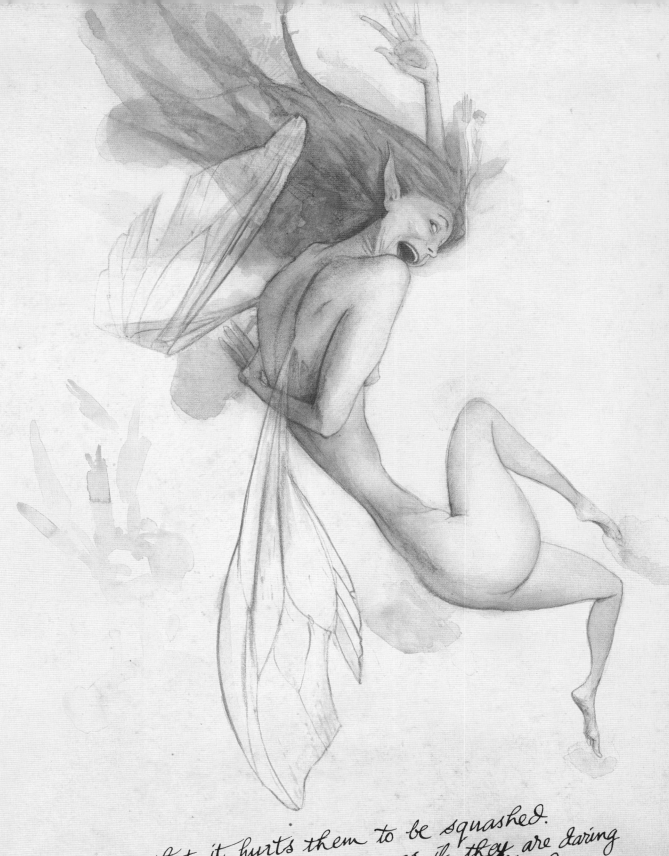

I do not believe that it hurts them to be squashed. They smile and wiggle and carry on so, as if they are daring me to press them and preserve them. And I do. It's the very least they deserve after the tricks they've played on Euphemia.

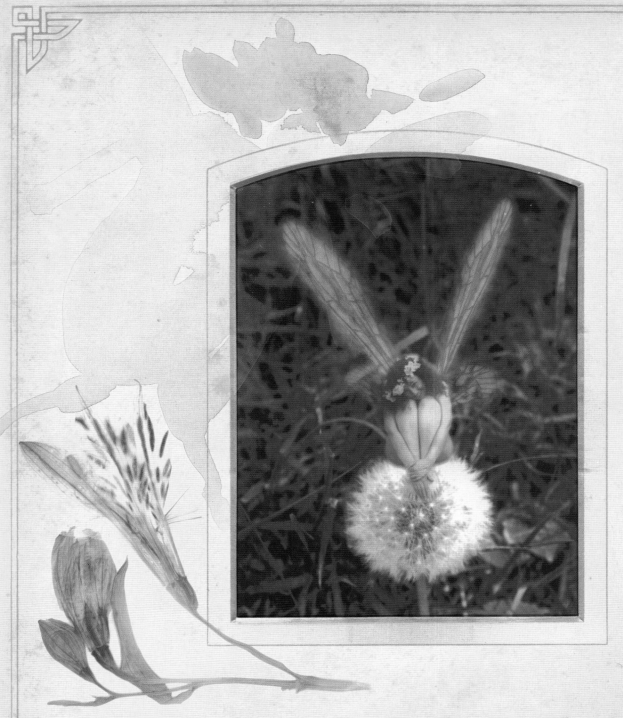

May 4th

 I could not help myself. For the past week I have heard them tapping at my window and have seen their lights beside my bed at night. What a joy there was upon my return. They have begged me to stay with them always. They have also told me fairy secrets that no human ear has ever heard. They pose for my camera most willingly, in poses that I would have not thought possible and certainly not advisable, but they come to no harm and take great delight in surprising me with new and interesting configurations each day.

 When I asked them who the man was that I danced with, their eyes grew round and they would not speak.

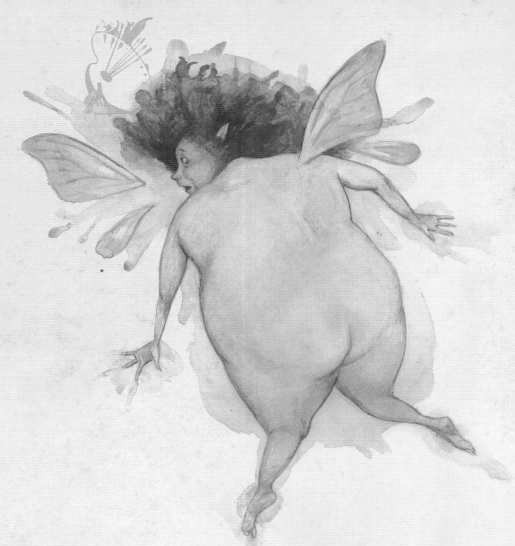

Oh Euphemia, what is to become of you?
You are too boldly reckless in your dealings with the
fairies. They are NOT to be trusted.

Fairy secrets! Fairy foolery I say!

Once a tiny fairy lying in the grass at the bottom of
the garden said that it would tell me a secret. I had
to stand on my head so that it could better reach my
ear. What a revelation! There was no secret — only
lots of sniggering laughs. They may have fooled me
once but never again!

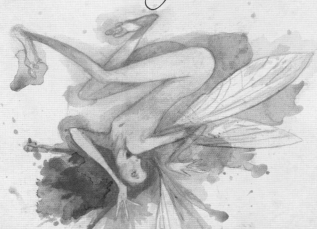

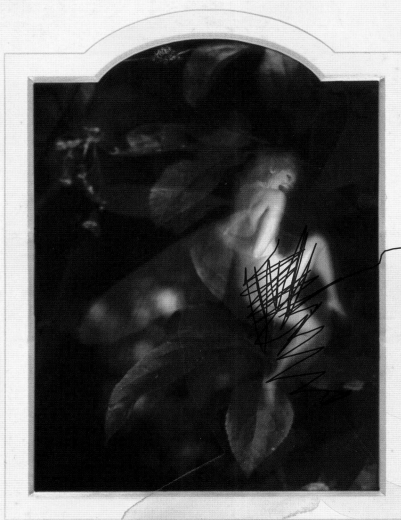

Oh!

May 7th

I felt his presence before I saw him. He was standing in the
dappled light of the glade, looking at me. In his hands he carried
a bowl of ripe plums, purple and bursting with juices. He held one to my
mouth and made me taste. I ate, and as I ate he kissed the juices from
my hands and then my lips, and so I willingly returned and more
those kisses from my beloved's lips, sweeter by far than any fruit could
ever be. We danced again, this time more slowly, and as we moved our
garments fell away as if by magic. I looked down at my uncovered self
and found it beautiful as I never had before. Perhaps this is truly as we
were meant to be. On the velvet green moss of the forest floor, we lay
down together........ our limbs entwined in a passionate embrace the like
of which I had only dreamed of before. I felt as though our hearts
were one heart and our souls joined as our bodies did in
unimagined bliss.

Oh dear!

Oh dear, dear, dear!

I could not read these dreadful words a moment longer and tried to scrub them from the page but this fairy insisted on reading them out loud and I had to still his little voice.

Oh Euphemia, you wanton, wicked girl!

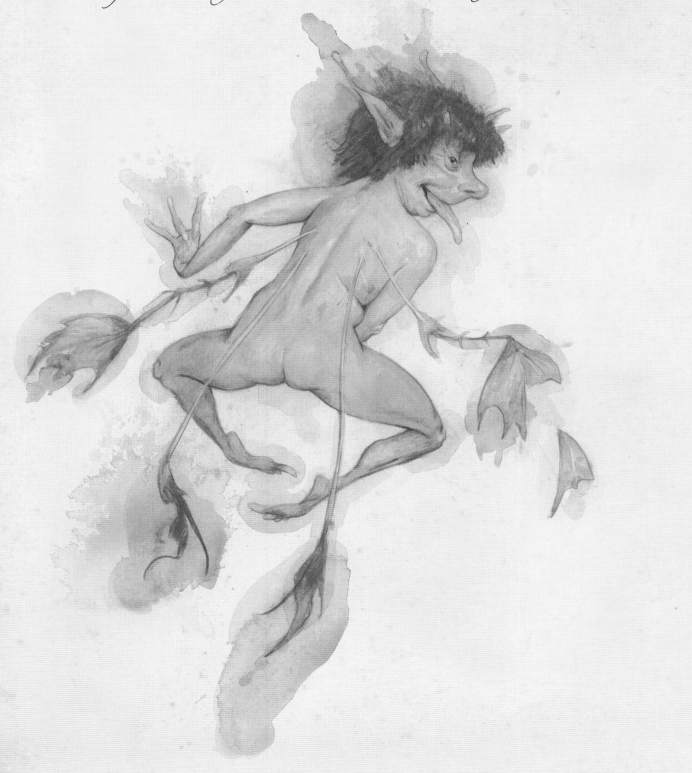

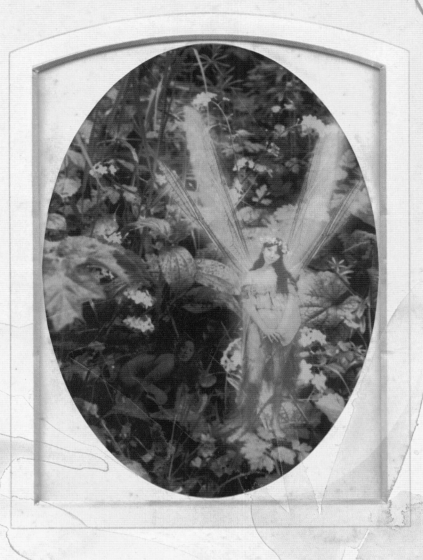

Do not eat their
know that you
bite. Too late I
fruit although
a fairy and
the squashing

May 8th

 Throughout the day the taste of fairy fruit has lingered in my mouth ~ a taste that turns all other food to dust upon my tongue. This evening I found a note from my beloved beneath my pillow.

> Meet me when the moon is full · on owl wing come
> On bat wing fly · Meet me where the star flowers
> bloom and taste this night with passions cry
> Come and kiss with rosy lips in glade and glen and
> bower and combe, and we shall weave a magic spell
> of darkness sweet upon love's loom.

fruit dear sister! Surely you must taste away if you so much as take a fear. I would never taste their once when I was younger, I squashed as an experiment, I put my tongue to — it tasted terrible!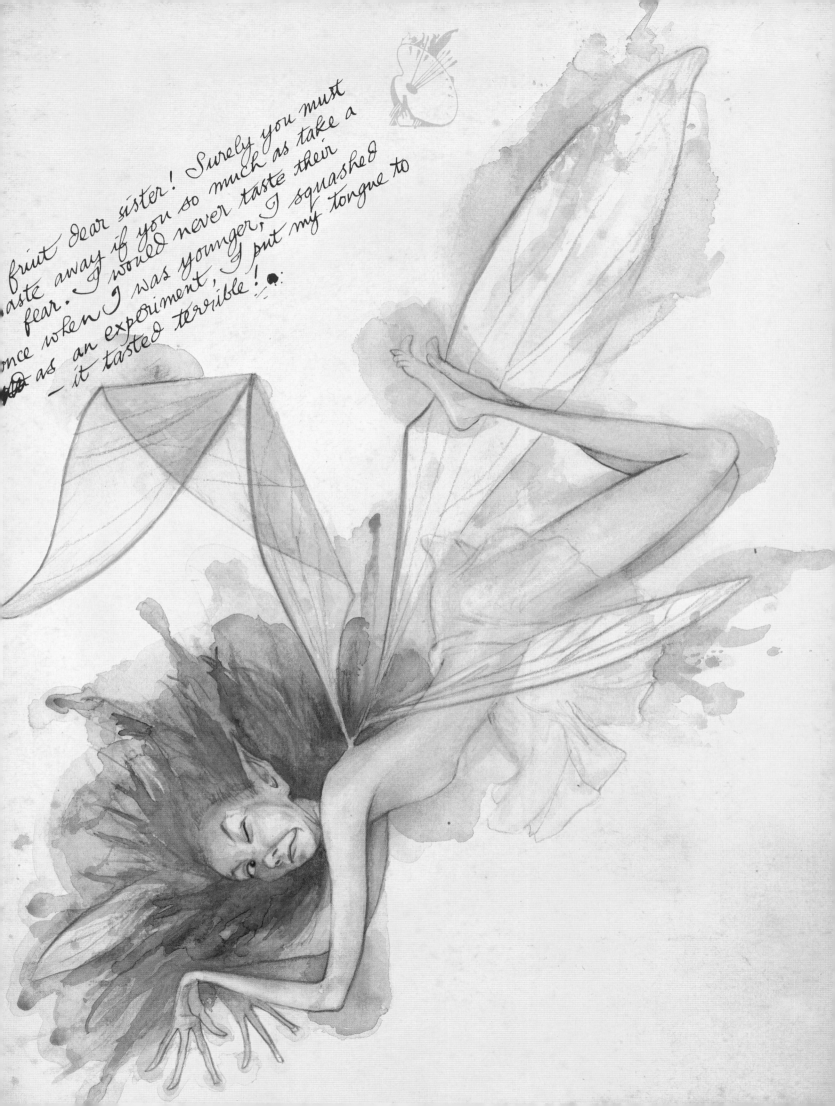

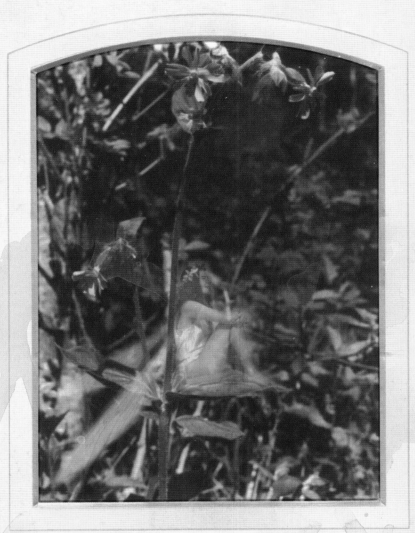

September 10th

This evening Uncle Humphrey patted me on the cheek and told me that I look very bonny indeed and healthier and fuller in figure than I was only a month ago. I have wondered at the tightness of my corset of late, which is curious since I do not eat much more than the fruit my lover feeds me.

The wind blew chill today as I walked in the wood. The little fairies huddled close to me and seemed to need the warmth of my body to sustain them. They grow quite sleepy and befuddled in the frosty air and I fear that they may need to sleep the winter away in some dark, warm nest until spring can wake them once again. There is a sadness in my love's eyes. Perhaps it is only the dying of the year that has made him so pensive.

I took refuge from the clouds of ~~fair~~ fairies in
Mr Dower's greenhouse. It is warm in here and sealed
from the world outside, and I thought that amongst
the orchids I could read in peace.

It was not to be. Why do they torment me like this?

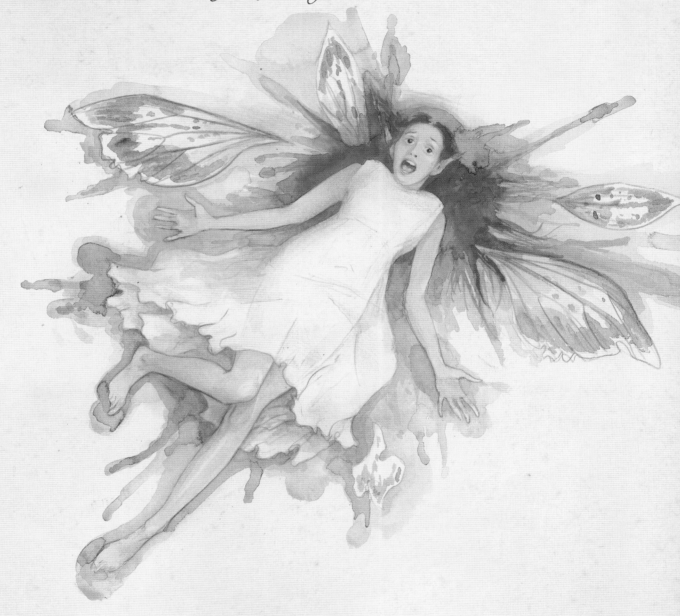

I am afraid Mr Dower is no longer speaking to me;
and, from his parting words, I am afraid that his
chances of winning the Village Orchid Prize have
been considerably reduced.

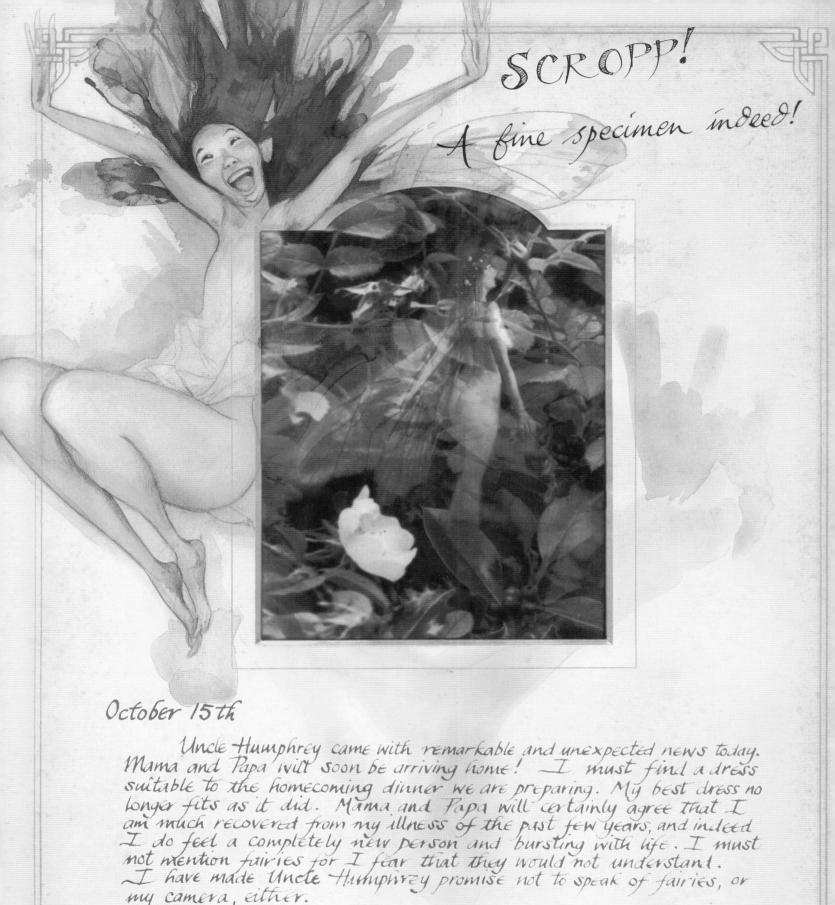

SCROPP!

A fine specimen indeed!

October 15th

Uncle Humphrey came with remarkable and unexpected news today. Mama and Papa will soon be arriving home! I must find a dress suitable to the homecoming dinner we are preparing. My best dress no longer fits as it did. Mama and Papa will certainly agree that I am much recovered from my illness of the past few years, and indeed I do feel a completely new person and bursting with life. I must not mention fairies for I fear that they would not understand. I have made Uncle Humphrey promise not to speak of fairies, or my camera, either.

A fairy flew up my skirts but I sat down immediately—
that put ~~an~~ an end to it's non-sense. I retrieved
it's delicate little body and laid it with great care
between these pages and pressed them firmly, but it
unfortunately revived and wriggled out and flew away.

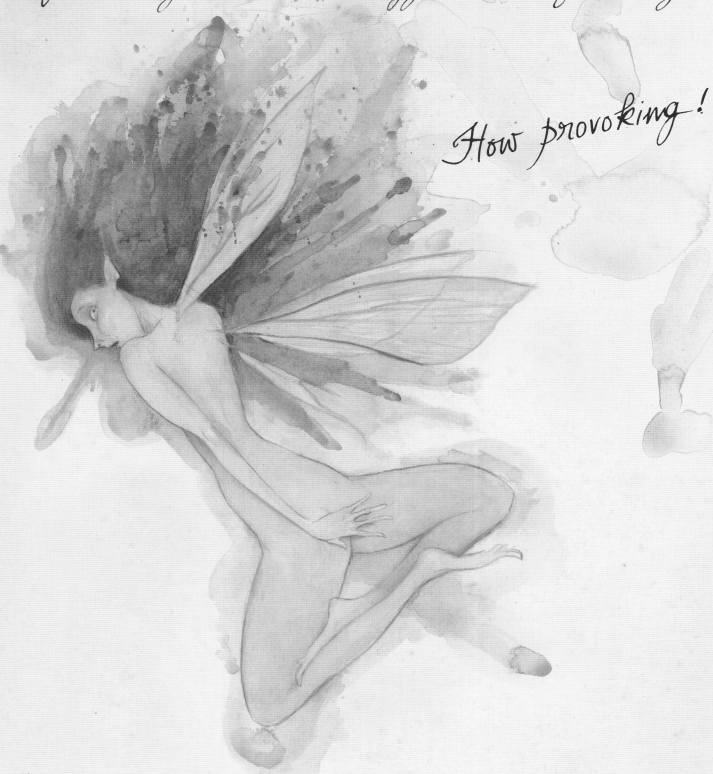

How provoking!

It was a great inconvenience to have to find another one
to replace it and then I could only find a lower grade
specimen, but it will have to do.

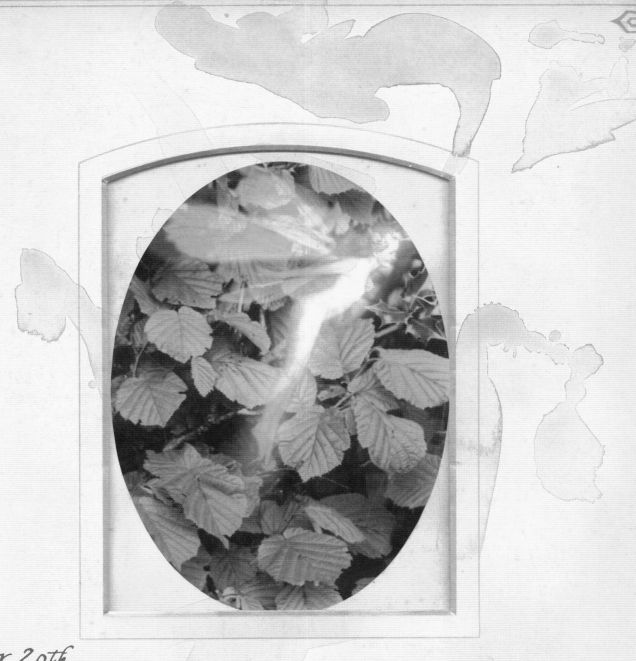

October 20th

Oh, desparate day! Miss Tandy has been dismissed in no uncertain terms and I am confined to my room. Uncle Humphrey has discovered an urgent appointment in Paris that cannot wait and so he will not be here to attest to my good behaviour these months past. From my window I can see the gardener turning over the earth in the flowerbed in which once the "Euphemia" grew. We shall have no more summer flowers — and no more gardener's boy either, for that matter.

Papa announced he would dismiss the gardener's boy after giving him a good whipping, but the lad has not been seen since the day before they returned. The gardener says that he does not know the boy's name or where he may be found, but says that he believes he may have been "a young gentleman fallen on hard times." ~ Such fuss and haste surround us all! Mama and I are to leave on an extended trip abroad. She has only just returned and now she is eager to depart again and take the 'cure' in some remote location on the Balkan coast. I am to be her constant companion. I have seen no fairies. Only Autumn leaves.

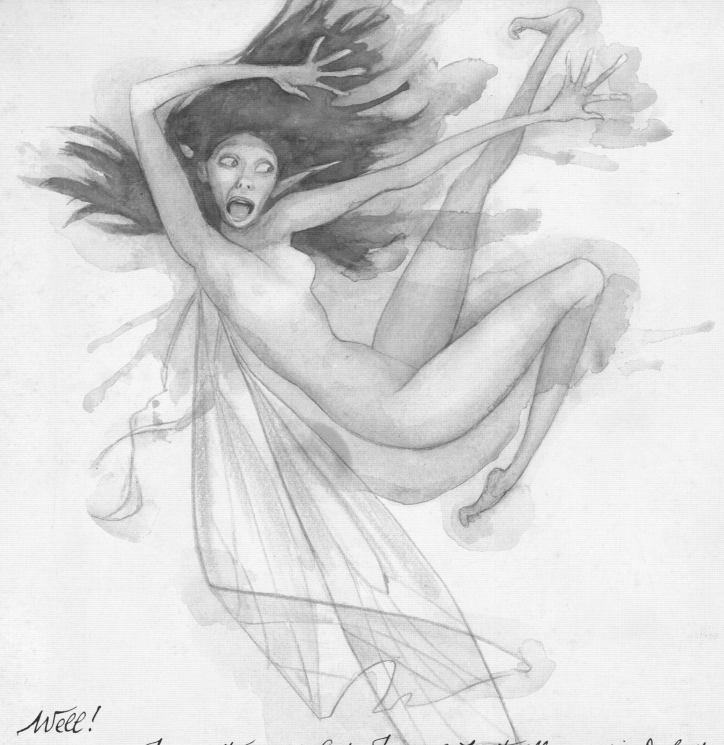

Well!

 I must say that I am not at all surprized about Miss Tandy. She had been terribly remiss in her duties, but why would Papa wish to whip the gardener's boy? Is naming a flower after Euphemia such a great crime? And why would Mama leave again so precipitously on a journey? Travels have always been exhausting to her. Usually, upon returning home, she retires to her bed for weeks on end, consuming nothing but beef tea to regain her strength.

 Truly this is most disturbing.

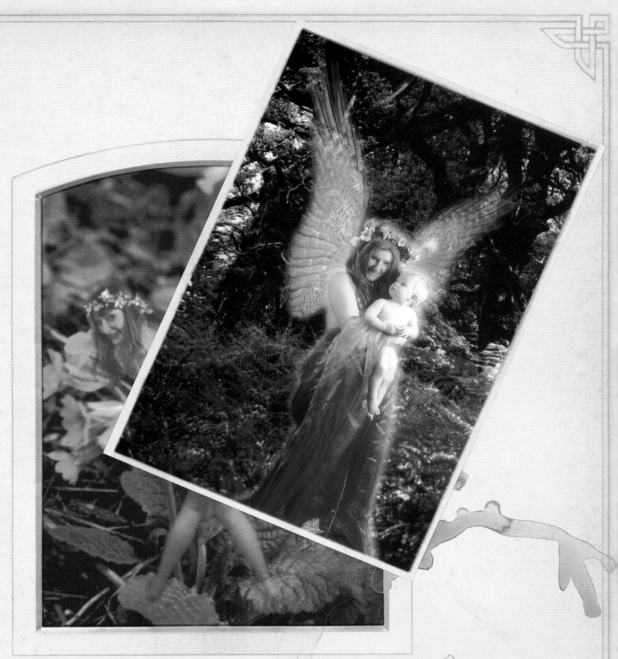

April 4th 1888

 Spring has returned to this dear land and so have we.
 Mama tells everyone of her little angel's gift, being so
called because she was thought to be beyond the years of childbearing.
A new addition to the family, a child for Mama ~ and a sister for me.
Oh, the mysteries of life that we are privy to. I love little Angelica
with all my heart, but I shall not take her walking in the wood,
nor shall I go again. My life is become what I must now be ~
rigid and confined, laced and buttoned and held tight to itself. I
read and draw and sew a pretty hem with stitches small as grains of
sand. I must not use my camera except for landscapes. I will
not be reminded of my folly or my joy.

 Uncle Humphrey has returned as well, although he is much
subdued. Father reprimanded him when he began to tell us about
horse racing at Royal Ascot and the "behatted lovelies" he observed
in the royal enclosure. Perhaps I will accompany him when I am
eighteen. I cannot believe that I have yet to reach my eighteenth
birthday for I feel that I have lived an entire lifetime in one
short year.

I am most exceeding puzzled. At first glance I thought this was the photograph that I took last year — the one that Papa took away for safekeeping. But it is not that photograph, for that is still locked securely in Papa's desk, and this fairy is not the fairy that I remember from that original picture. She is much more beautiful.

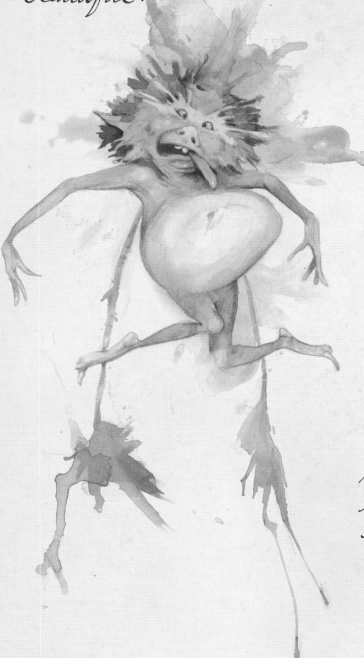

SCKOPP!

Where did it come from? Who sent it to me? And who could have written this message on the back? It must be intended for me because it is my birthday but I can't imagine where it came from.

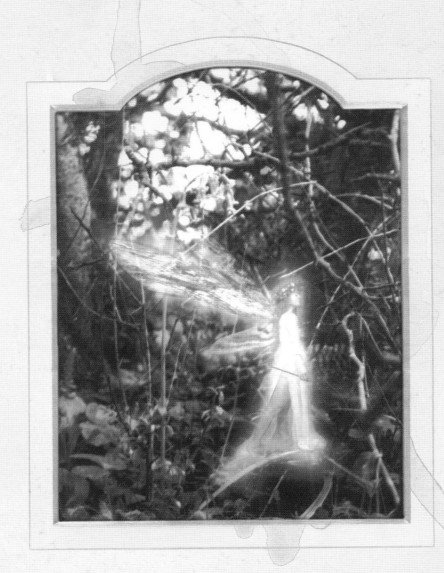

September 2nd 1891. They are here! — After all these years!

I thought them gone forever, but no, they call me. I hear them every night.

I walked to the edge of the wood today. They did not show themselves at first but I waited patiently and soon enough I saw three of them peering at me from the shadows. They are so lovely! Could I have forgotten the beauty of these beings, or have they grown in fairness as I have grown in years? We were shy together, not boldly embracing as long lost friends but looking and touching gently as those who are not certain if a welcome will do. But welcome there was.

Euphemia — have you learned nothing from your visits to the wood? I despair of you, I really do.

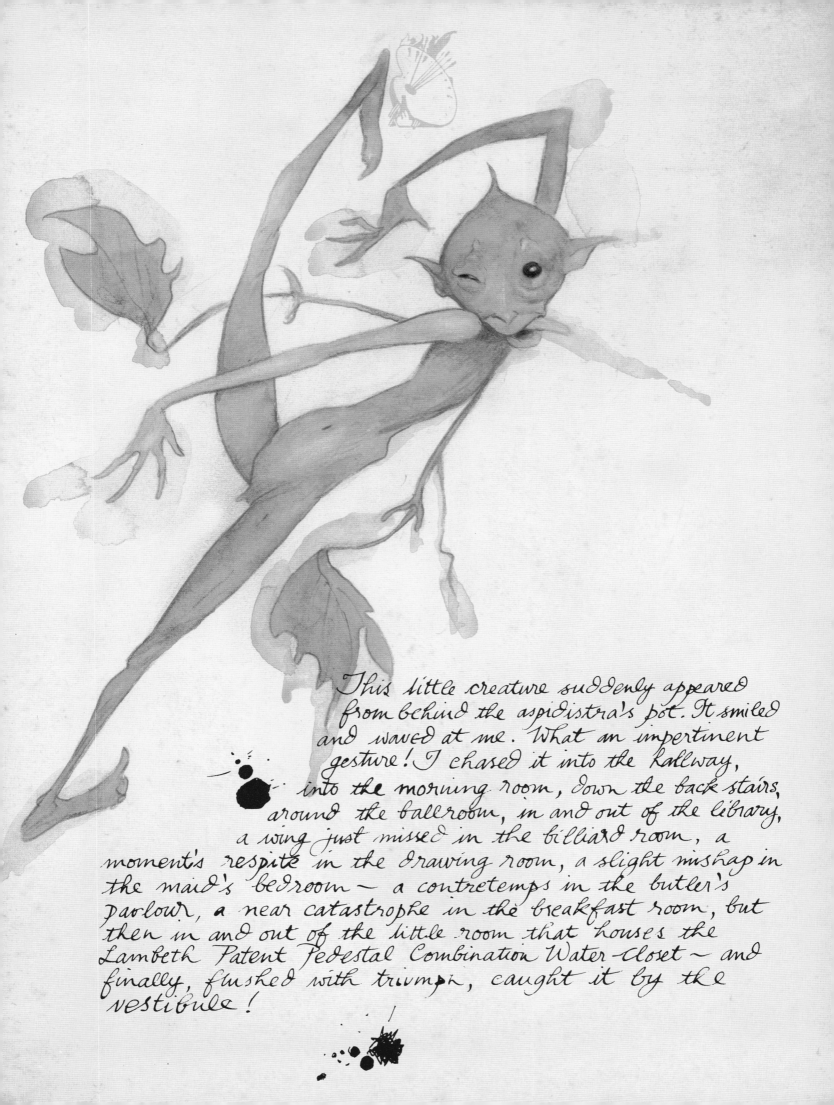

This little creature suddenly appeared
from behind the aspidistra's pot. It smiled
and waved at me. What an impertinent
gesture! I chased it into the hallway,
into the morning room, down the back stairs,
around the ballroom, in and out of the library,
a wing just missed in the billiard room, a
moment's respite in the drawing room, a slight mishap in
the maid's bedroom ~ a contretemps in the butler's
parlour, a near catastrophe in the breakfast room, but
then in and out of the little room that houses the
Lambeth Patent Pedestal Combination Water-closet ~ and
finally, flushed with triumph, caught it by the
vestibule!

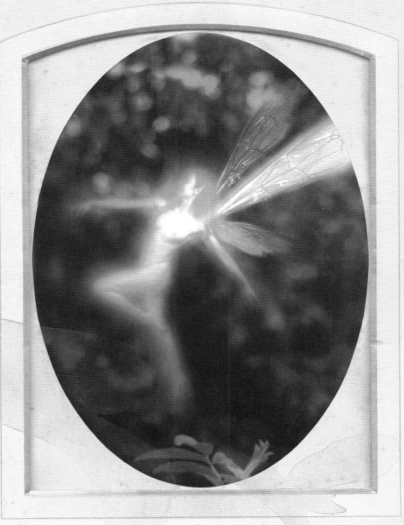

September 3rd

I am alive again! The grass sparkles like jewels and flowers bloom and dew is fresh upon my feet. The fairies tell me secret things and silly things and riddle and rhyme until we nearly faint with laughter, but when I ask them of the man with the eyes like stars and skin shining like the harvest moon, they shake their heads and will not say a word. They have made for me a fairy banquet, hoping to entice me with their fare. It was a most magnificent effort and I praised them whole-heartedly, but still it was not fairy fruit from his fair hand.

Angelica is such a bonny child. She laughs and frolics in the garden always under the watchful eye of Miss Simkin. She is such a determined little thing. Often I see her batting the air with chubby fist or stamping on the ground as though she would press what-ever lies beneath her foot into submission. Her childish fancies hold no trace of care or any thought beyond whatever may be next for tea. And as I sit writing this I hear Angelica's dear voice shouting, "Got one, Simmy, got one!" The precious thing must be catching butterflies.

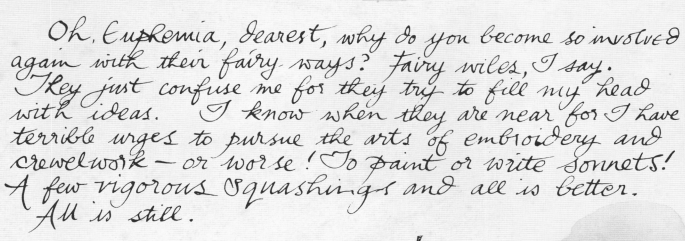

Oh, Euphemia, dearest, why do you become so involved
again with their fairy ways? Fairy wiles, I say.
They just confuse me for they try to fill my head
with ideas. I know when they are near for I have
terrible urges to pursue the arts of embroidery and
crewelwork — or worse! To paint or write sonnets!
A few vigorous Squashings and all is better.
All is still.

THRAMP!

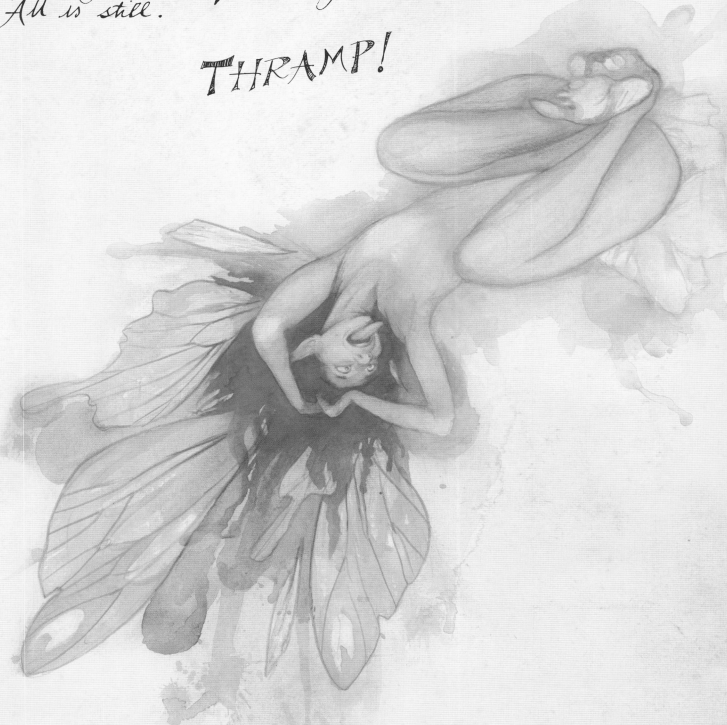

Come away to your true home beloved Euphemia
Your world wraps you in heavy chains and we
Would set you free forever

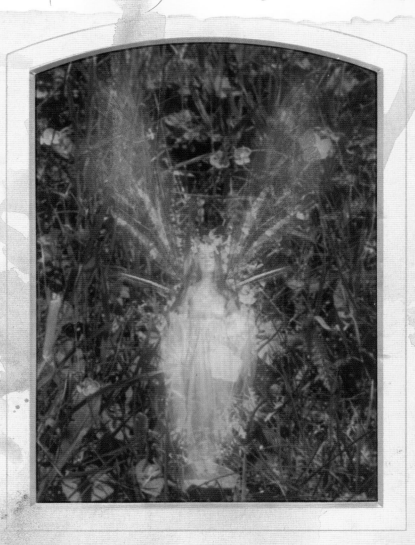

September 10 th

The fairies know and will not tell, but I see it in their
eyes — expectant, and excited and afraid.

—He is near. My heart whispers it to me, and I find myself
smiling without cause or reason.

Does she not understand? This is exactly when they are
at their most tricksy — them being all nice and entranc-
ing. I've heard their lilting songs, all sweetness and
la-la, making you feel all swooney and tickly
inside.

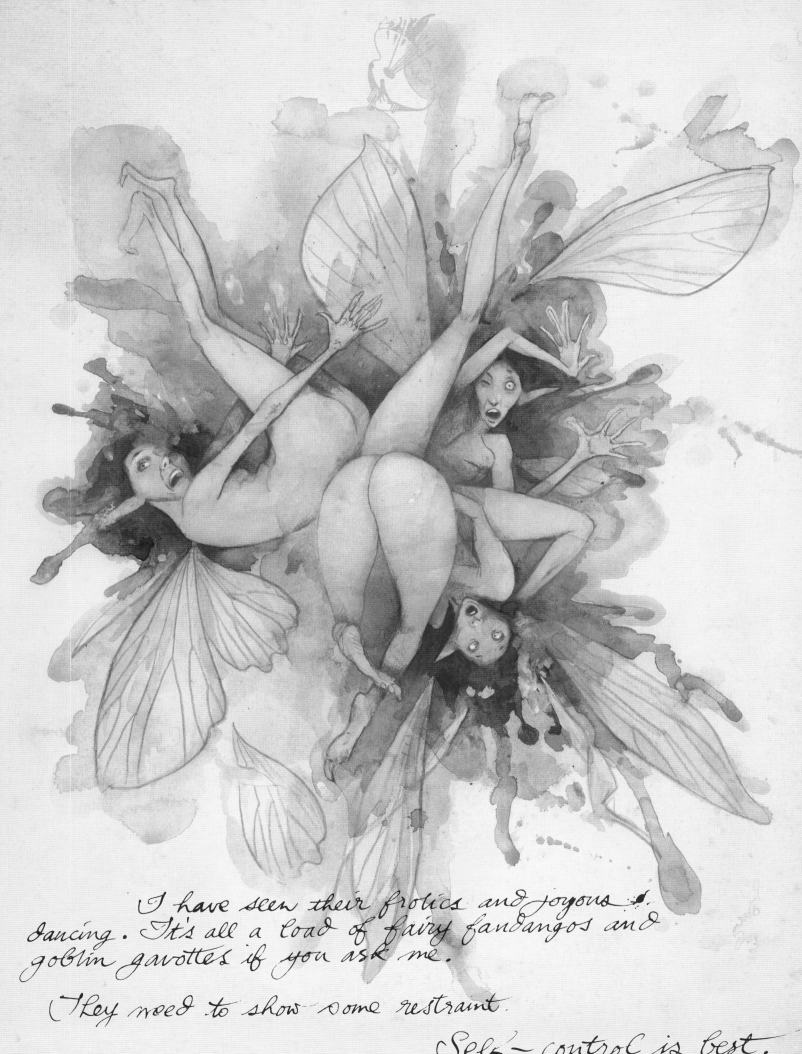

I have seen their frolics and joyous
dancing. It's all a load of fairy fandangos and
goblin gavottes if you ask me.

They need to show some restraint.

Self—control is best.

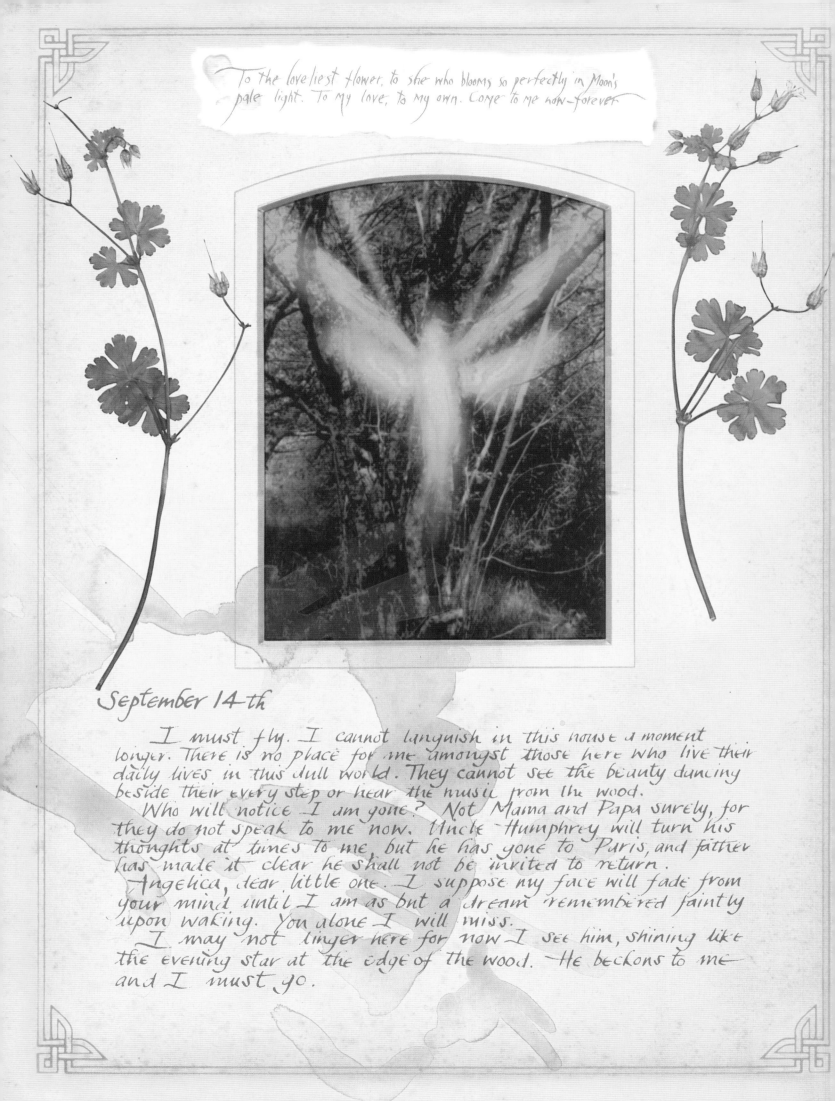

To the loveliest flower, to she who blooms so perfectly in Moon's pale light. To my love, to my own. Come to me now—forever.

September 14th

I must fly. I cannot languish in this house a moment longer. There is no place for me amongst those here who live their daily lives in this dull world. They cannot see the beauty dancing beside their every step or hear the music from the wood.

Who will notice I am gone? Not Mama and Papa surely, for they do not speak to me now. Uncle Humphrey will turn his thoughts at times to me, but he has gone to Paris, and father has made it clear he shall not be invited to return.

Angelica, dear little one. I suppose my face will fade from your mind until I am as but a dream remembered faintly upon waking. You alone I will miss.

I may not linger here for now I see him, shining like the evening star at the edge of the wood. He beckons to me and I must go.

Not dead?

Are you not dead for all these years?
Not taken by the angels but run off with the fairies!
How cruel, my sister, to abandon me then!
 But why has everyone been lying to me all these years?
Why would Mama and Papa decieve me this way?
 I must speak with them upon their return
tonight — I must understand what all this means.
 The fairies are buzzing in my ears worse than
ever — I could scream! Perhaps I can escape
them in the Summerhouse — and look for the
promised birthday gift. I've been hoping for a

~~Goat Cart~~ or OR

Kahnweiler's improved
Patent Cork Life Preserver.

Christina Rossetti's
Collected Anthology of
Merry Drawing Room Tapes.

Dr Scott's Invigorating
Electric Corset.

Really,
 I do hope it's a Goat Cart!

Tonight Mama and Papa will return from London, and if I am a fortunate girl they will remember that it is my birthday today. Some years they forget.

The clouds of fairies that have tormented me today have finally left me alone, to my extreme relief.

It is too dark now to see the edge of the woods and any person who might be standing there. And I do not wish to see anyone in the woods. I would not go even if I were called.

And yet I wish I had a sister here. It would have been good to have a sister who loved me, or some one who would hold me tightly and sing to me.

None of this exists. Once I have closed this album I shall never open it again.

Oh, a fairy at the edge of the candlelight. I can see it waving something pale and flat.

Something objectionable I have no doubt.

I've searched for at least an hour and still I've found no birthday gift. If only this silly fairy would stop distracting me.

But no use! No present, no sister, only broken fairy promises.

Oh, the wretched thing! I'll leave here and I'll never come back and I'll never press another fairy — just this last one...............

SNAP!!

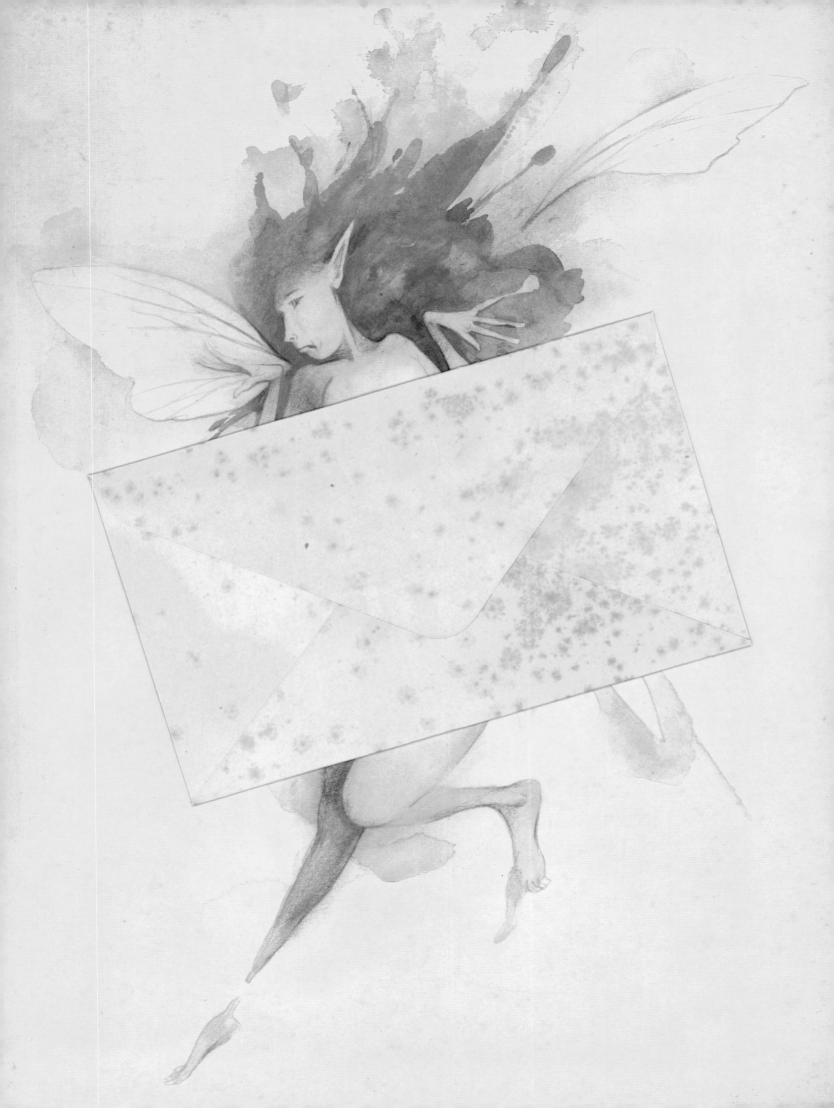